South Coast

MASSACHUSETTS

Robert N. Zieb

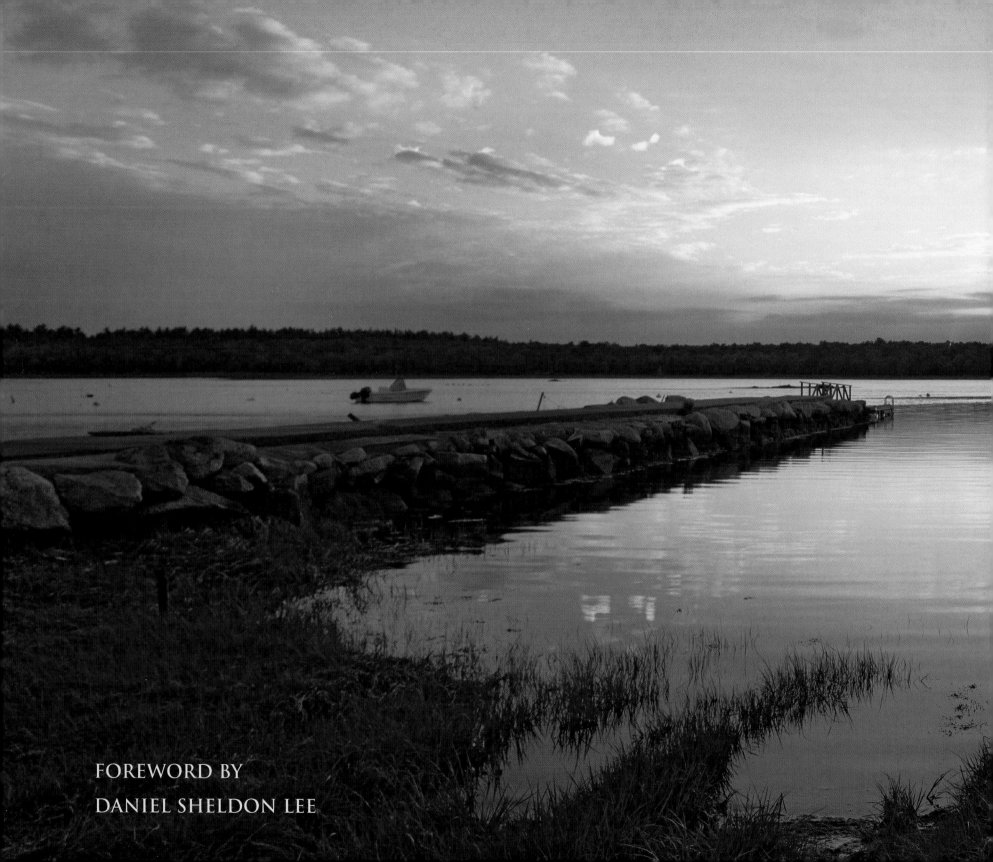

FOREWORD BY
DANIEL SHELDON LEE

South Coast
MASSACHUSETTS

PHOTOGRAPHS BY ROBERT N. LINDE

COMMONWEALTH EDITIONS

BEVERLY MASSACHUSETTS

TO CARRIE AND TEDDY

ISBN-13: 978-1-889833-97-2
ISBN-10: 1-889833-97-5

Library of Congress Cataloging-in-Publication Data

Cover and interior design by Anne Lenihan Rolland
Printed in South Korea

Title page: Sunrise over Weweantic River, looking toward Wareham
Contents page: Sea smoke over Mattapoisett Harbor

Commonwealth Editions is an imprint of Memoirs Unlimited, Inc.,
266 Cabot Street, Beverly, Massachusetts 01915.
Visit us on the Web at www.commonwealtheditions.com.

E-mail Robert Linde at RNLinde@comcast.net.

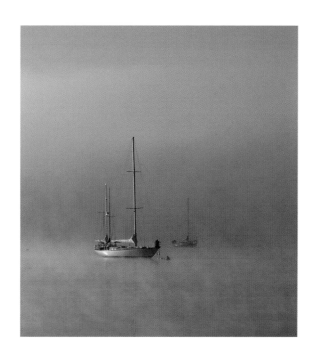

CONTENTS

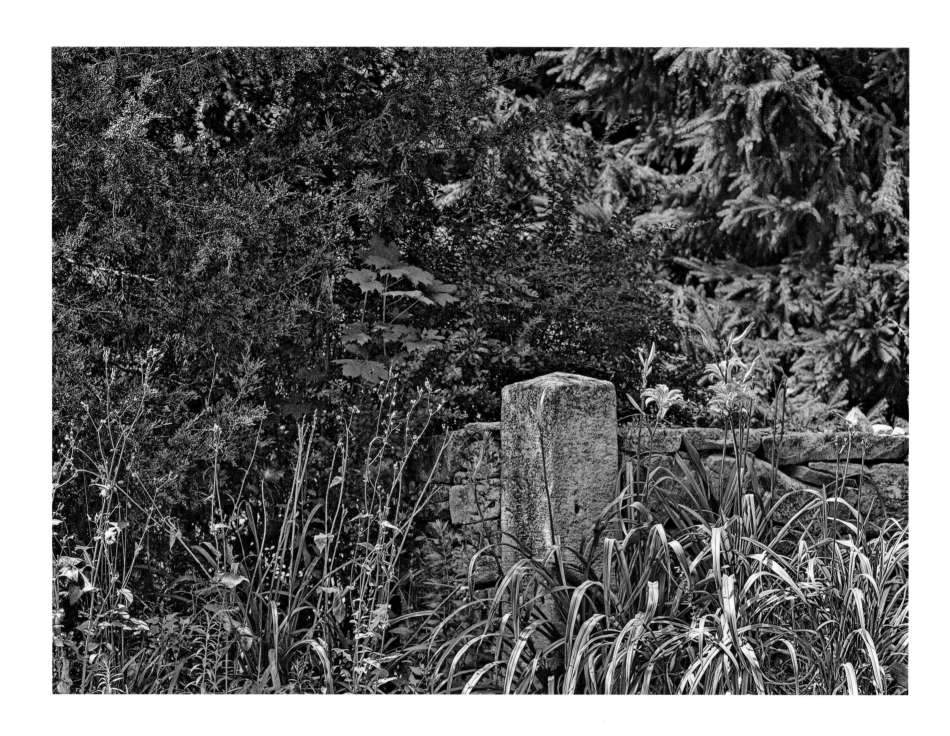

6 Russell's Mills Road, Dartmouth

THE SOUTH COAST

The southwestern coastline of Massachusetts is a land of its own, defined by the warm, shallow waters of Buzzards Bay. As Bartholomew Gosnold, the discoverer of the Bay, astutely noted in 1602, the South Coast is a place of streaming sweetwater rivers that meet many fine harbors.

The Wampanoags erected temporary summer villages on the coast here to fish; to harvest the plentiful oysters, quahogs, and other shellfish; to grow corn, beans, and squash; and to play lacrosse and gamble in congregations of thousands on the beaches. They retreated inland in winter, just as seasonal residents of the area do today. Their coastal villages were typically sited near river mouths and on hills, the same sites on which colonists later built their towns and cities.

Two of these South Coast towns have retained approximations of their Native American names: Mattapoisset ("Place of Rest") and Acushnet ("At the Head of the River"). The English colonists, like the Wampanoags before them, spurned roads in favor of doing their business by water, scooting from harbor to harbor in hatchet-bowed catboats, and racing to and from major ports such as Providence and Boston in packet schooners. The few main roads they did have were built directly over native paths. To this day you'll find few major roads on the South Coast, a fact that has contributed significantly to the region's independent character and community spirit.

"South Coast" means different things to different people. To environmentalists like myself, the South Coast is part of a wondrous natural ecosystem, Buzzards Bay, that was recognized in 1984 by our federal government as a national environmental treasure in need of protection. To others, the South Coast is an economic region to be actively promoted and developed. But I suspect that for most residents, the South Coast is simply that magical interplay of sea and shore that ranges from the head of Buzzards Bay to its far-flung western boundary in Westport.

The region may be said to include the towns of Wareham, Onset, Rochester, Marion, Mattapoisett, Fairhaven, Acushnet, New Bedford, Dartmouth, and Westport—though other towns also may seek to wear the mantle of "South Coast." Wareham, which can be considered the gateway to the region, is a miniature city that, like New Bedford, struggles with urban issues; but it also boasts impressive waterfront residences and a vibrant natural shoreline. Onset, once a salt producer and later a famous resort playground of the rich, has managed to retain much of its Victorian charm and is now a diverse community of multiple ethnicities somewhat reminiscent of Oak Bluffs on Martha's Vineyard.

Rochester, Marion, and Mattapoisett were originally one town that split just before the Civil War. Land-locked Rochester was historically a farming and logging village. Today, it shares with its neighboring town Acushnet a rural landscape characterized by horse farms and fruit orchards. Marion, with its proper white picket fences, old-fashioned general store, and sprawling, stately Tabor Academy, was known in the past as a salt producer and a home for sailors and wealthy sea captains. Mattapoisett, now a fine resort community, was known historically for shipbuilding and whaling. The town presented New England with more than four hundred ships that fueled the whaling age. One of these was the *Acushnet*, on which Herman Melville voyaged, a

journey that formed the basis for *Moby Dick*. Another was the *Wanderer*, the last whaling ship to sail from New Bedford; she went to pieces on nearby Cuttyhunk Island's reef in 1924.

New Bedford, Fairhaven, and Acushnet form the great port, or working harbor, of the South Coast, then as well as now. New Bedford, a city of one hundred thousand, serves as the commercial and cultural hub of the region. It was famous first as a whaling port, then as a leader in textile manufacturing. Today, commercial fishing and fish processing play important roles in its economy. Thoroughly fouled by PCBs and other pollutants from many years of unregulated industry, New Bedford's grand working harbor is currently undergoing a massive EPA-funded cleanup that is helping spur renewal. Fairhaven, across the harbor from New Bedford, fought the first naval battle of the American Revolution in 1775, prospered along with New Bedford during the whaling era, and today is known for its quality shipbuilding and ship-repair facilities.

In colonial times, Dartmouth—which then included what are now Acushnet, Fairhaven, New Bedford, Dartmouth, and Westport—broke away from Plymouth for religious reasons. Today, Dartmouth and Westport, known historically for farming, whaling, and shipbuilding, retain much of their open land and traditional seafaring character due to major preservation efforts. The Slocum River is now the beneficiary of environmental restoration, and the marshes at the confluence of the two branches of the Westport River are now home to Massachusetts's most robust population of ospreys, restored with a large dose of local effort after the tragic folly of the DDT years.

My personal impression of the South Coast has always been "Vermont on the ocean, minus the mountains," for, like northern New England, much of this region is still graced by forest, field, river, and bog.

The South Coast is a land that produces its own cheese, a soft, delicious blue. Its vineyards yield champagnes coveted by U.S. presidents, its breweries beers that finish in quiet celebration days spent on the water. In the fall, farm stands pour forth sweet yellow corn and succulent red tomatoes. Here you can buy fresh-baked bread at places other than gourmet shops. The invigorating sight of crimson cranberries framed by bright blue skies, for most of us just a romantic calendar shot, is a reality here, part of everyday life.

The South Coast is a place where fishing boats unload dense mounds of sweet sea scallops from George's Bank, where the concept of the "catch of the day" still exists, and where average folks can still go down to the waterfront with their kids to fish. It's a place where you can see the strong bones of the land, rooted up by farmers and strewn along the roadsides in long granite works of art called stone walls, festooned with orange, red, and yellow lilies. It's the kind of place where men judge each other less on vocation than on the size of the striped bass they caught in the local fishing tournament; where each community honestly believes theirs is the best clambake around; and where birders are taken seriously. Locals can tell that you're not from around here if you place emphasis on the first, rather than the last, syllable of a place name. It's "WARE-HAM," not "WAREum," thank you very much.

Finally, the South Coast is a place where people care about and preserve the character of their communities and their land with a dedication that is inspiring. And that last value may prove critical, for the next thirty years will likely see a population explosion on the South Coast. The success with which suburban sprawl is controlled and managed will determine both the future character of the region's communities and whether Buzzards Bay survives as a healthy, clean-water ecosystem valued for swimming, boating, and fishing.

The South Coast is a place where men have traditionally squared off with the sea with remarkable success. In the nineteenth century, the greatest whaling fleet in the world sailed from New Bedford, making that city immensely rich. Our country's most productive fishing fleet is based here today. Captain Joshua Slocum, the first man in history to sail singlehandedly around the globe,

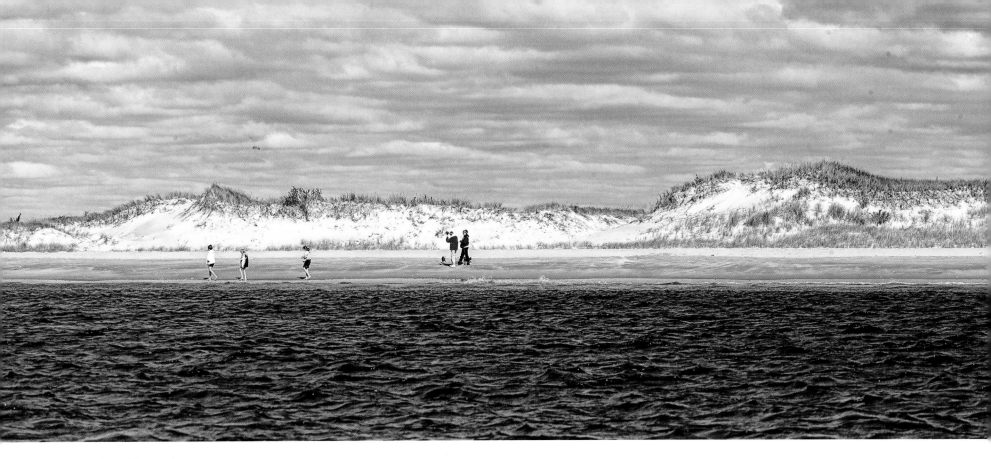

Cherry and Webb Beach, Westport

rebuilt his sloop *Spray* in Fairhaven in 1894. This maritime heritage remains strong in South Coast communities today.

A long marriage with the sea has resulted in a rich multicultural presence on the South Coast today. Thousands of people claiming Wampanoag descent are still scattered across the region. The hard-nosed Yankees, some descendents of the original Pilgrim landowners from Plymouth and New Bedford whaling families, are still amply represented. But there are also many Portuguese, Cape Verdeans, Norwegians, and other ethnic groups that first arrived as labor on the whaling ships, later worked in the vast textile mills of New Bedford, and have since helped define the culture, and overall appeal, of the region. It may come as a surprise to newcomers (especially those from Cape Cod) that nobody on the South Coast is alarmed when Portuguese linguiça shows up in their New England clam chowder. And no one looks twice at a giant, hammer-wielding statue of Thor, the Norse god who provides protection from evil, erupting from the roof of a Norwegian fisherman's home. Why? Because above all else, the people of the South Coast recognize and celebrate the fact that, despite differing backgrounds, this place and its people are, and always have been, about the sea.

Daniel Sheldon Lee
Autumn 2005

GATEWAY

Wareham celebrates itself as the "Gateway to Cape Cod," but to visitors from the north, it's the Gateway to the South Coast. Wareham has a business center for the surrounding villages and a number of vacation communities along its intricate shoreline. Onset, formally a part of Wareham, has its own personality. It is a summer beehive with a noted blues festival and parties galore. If you like lovely beaches and lots of activity, Wareham and Onset are the places to see.

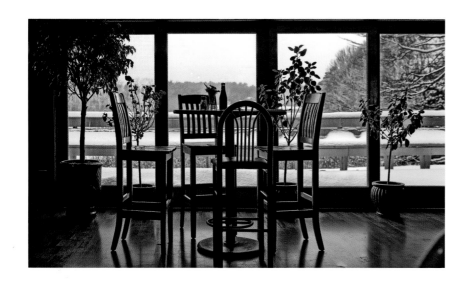

Above: Snowy day at the Gateway Tavern, Wareham

Right: Marina at the Narrows, Wareham Center

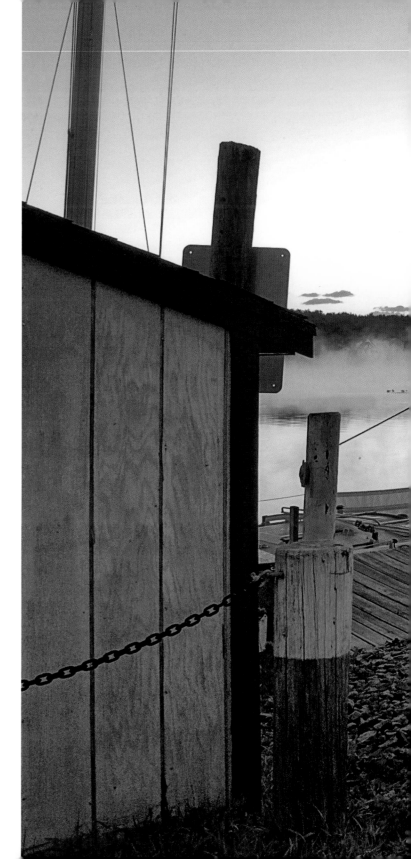

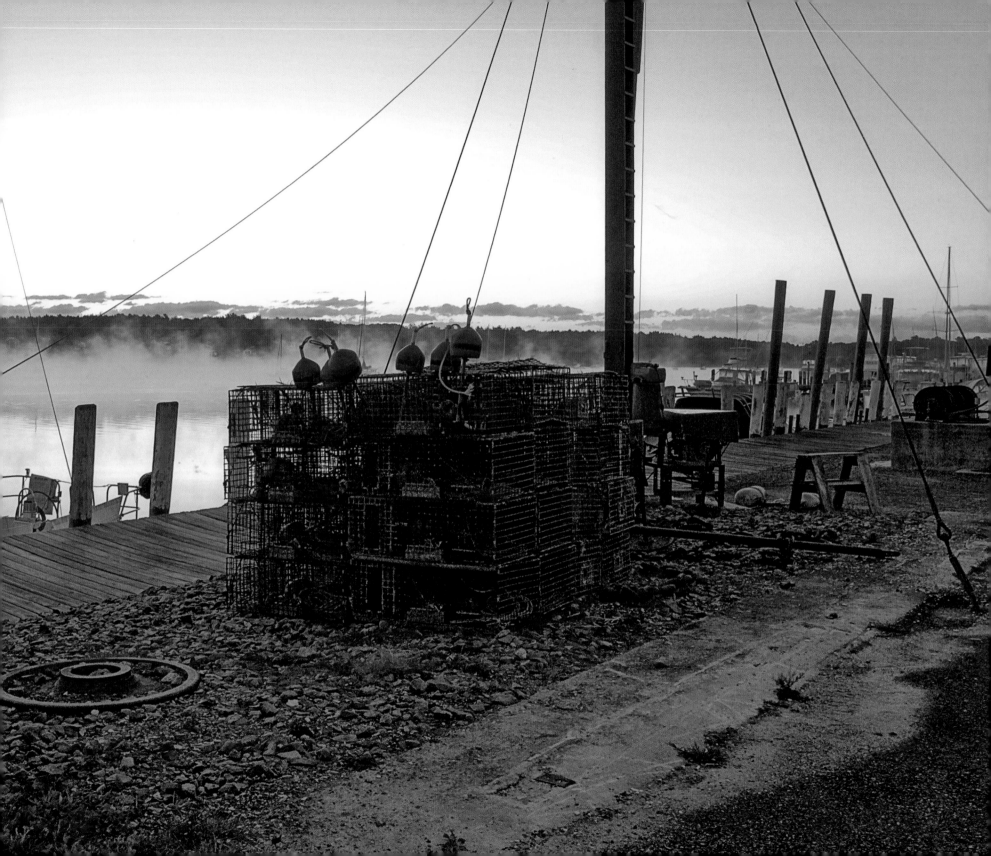

12 Marsh at Little Harbor, Wareham

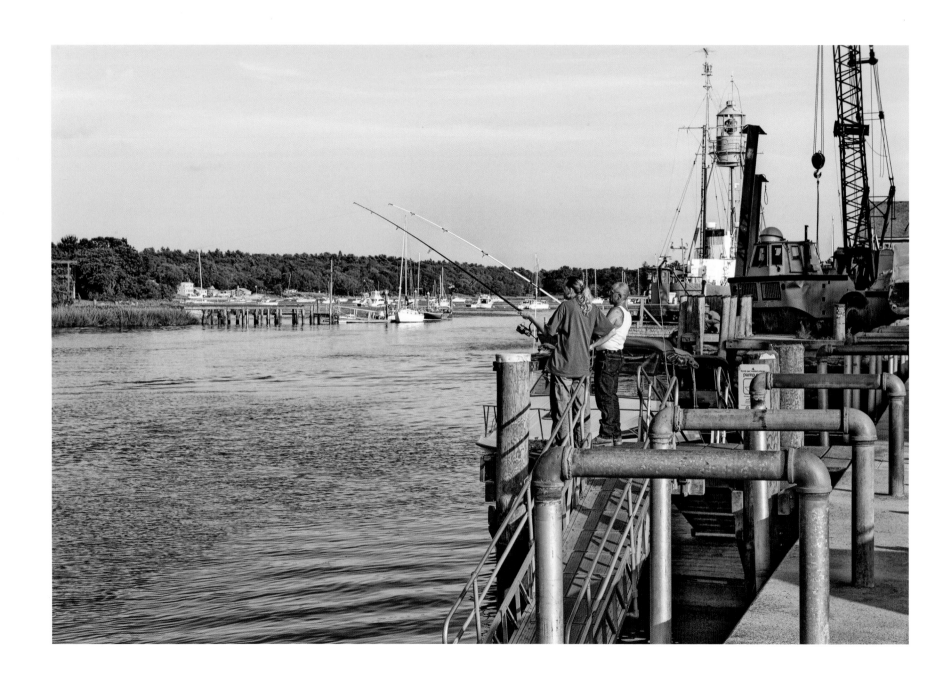

14 Fishing at Besse Park, Wareham

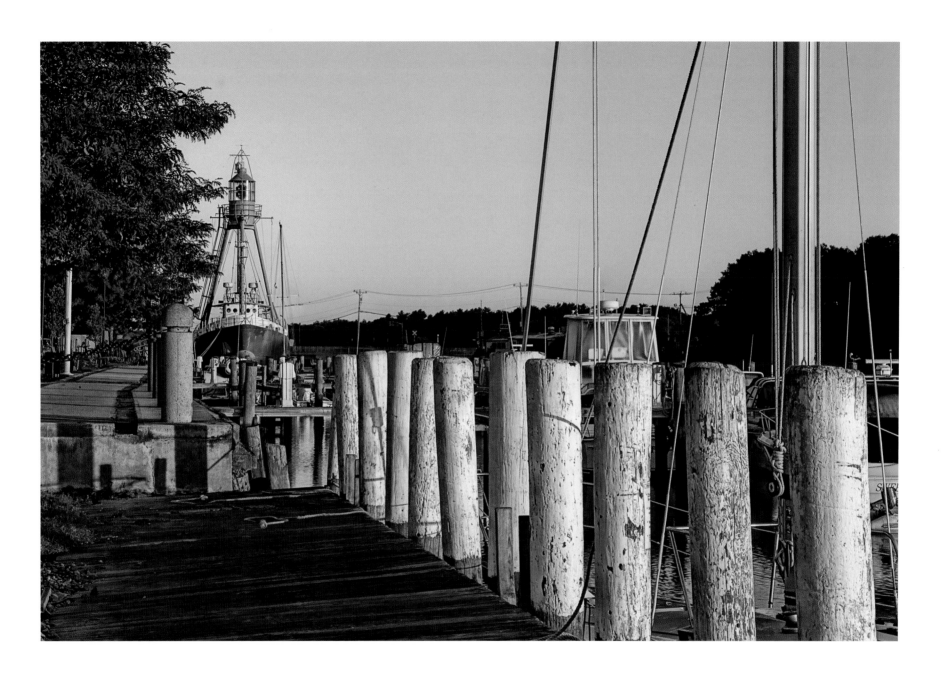

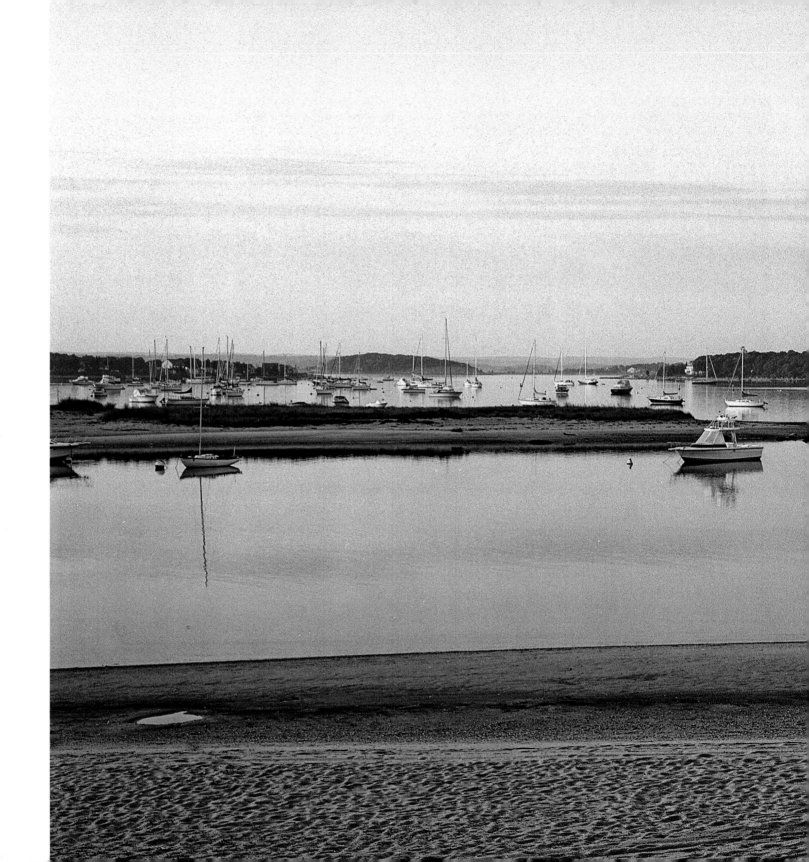

Onset Bay

16

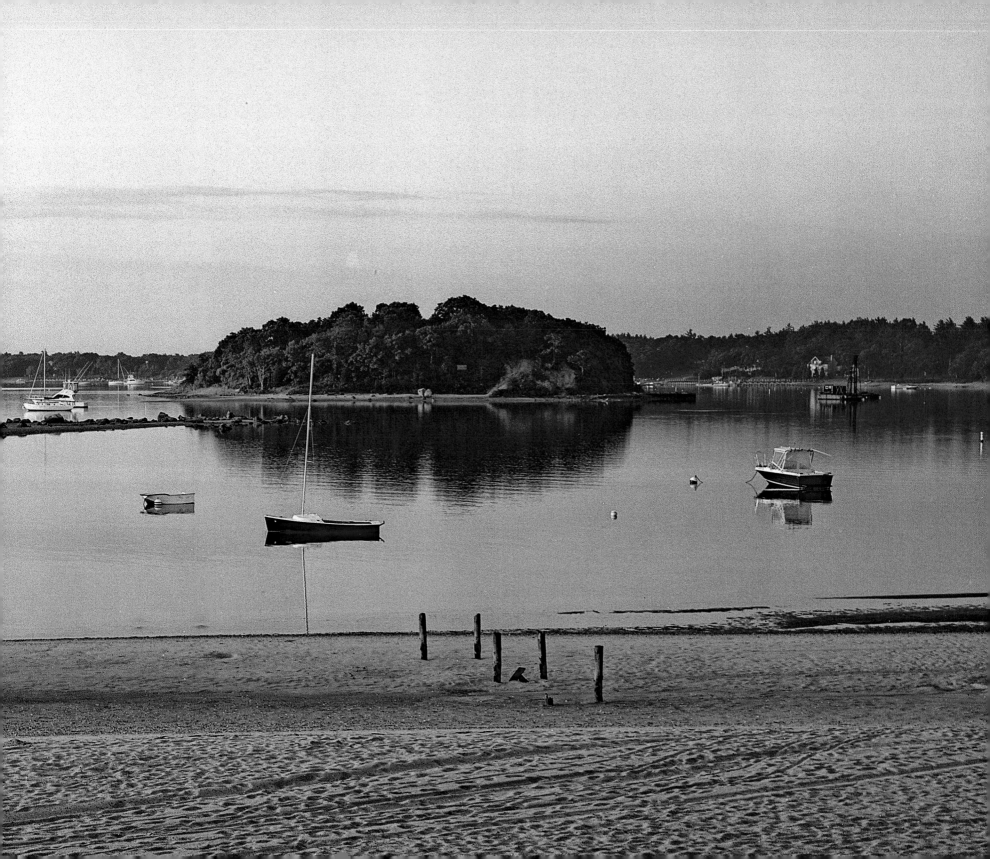

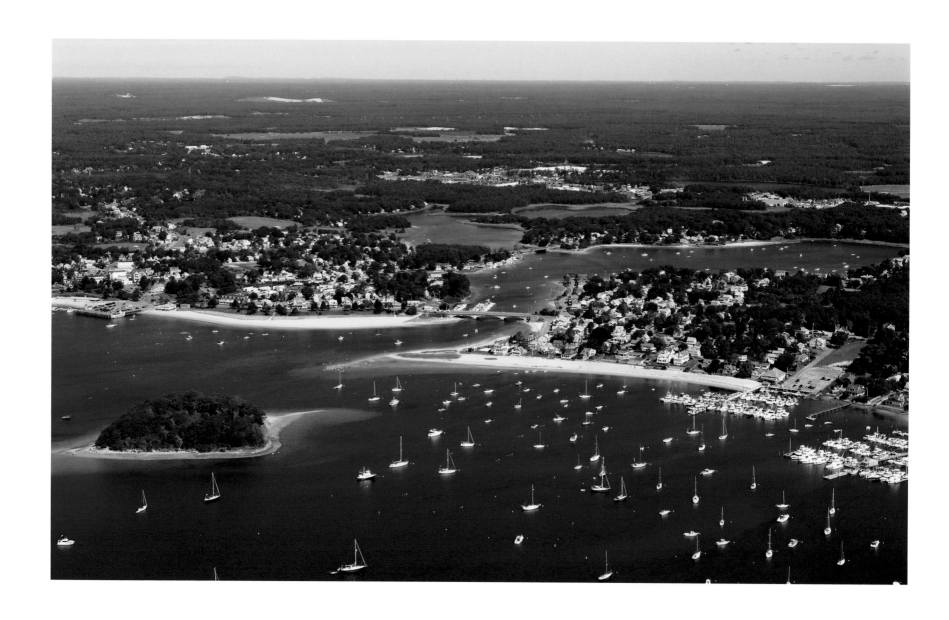

18 Onset Bay, with Wickets Island at left

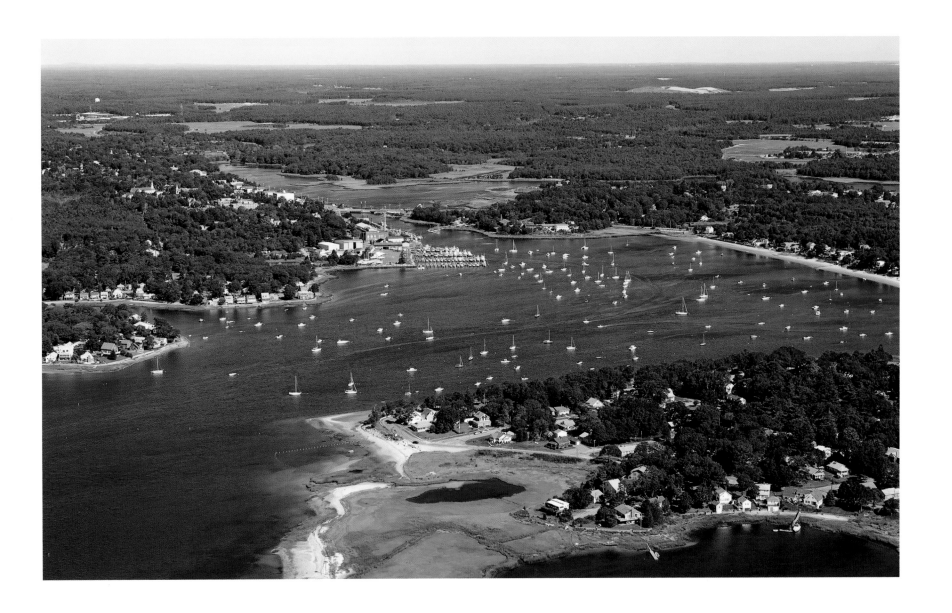

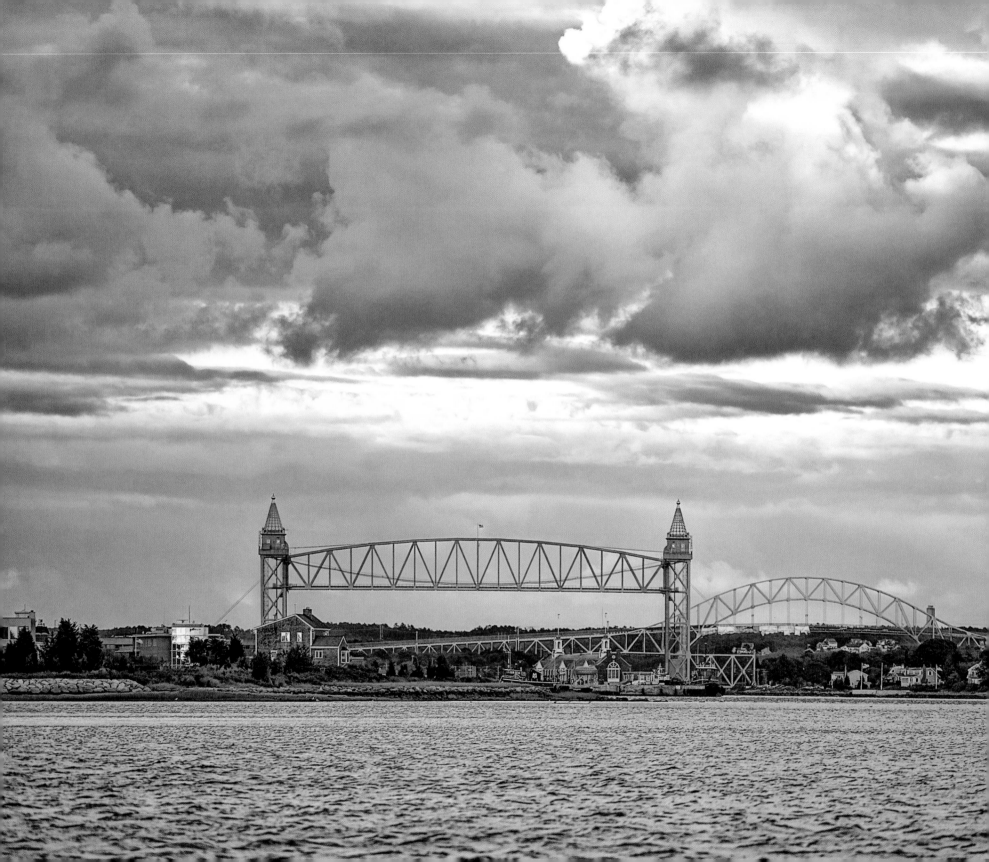

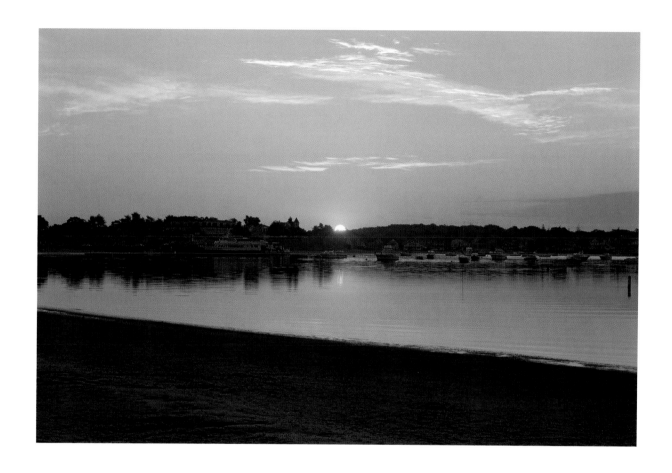

Above: Summer sunrise over Onset Bay
Left: Cape Cod Canal entrance, seen from Onset Bay 21

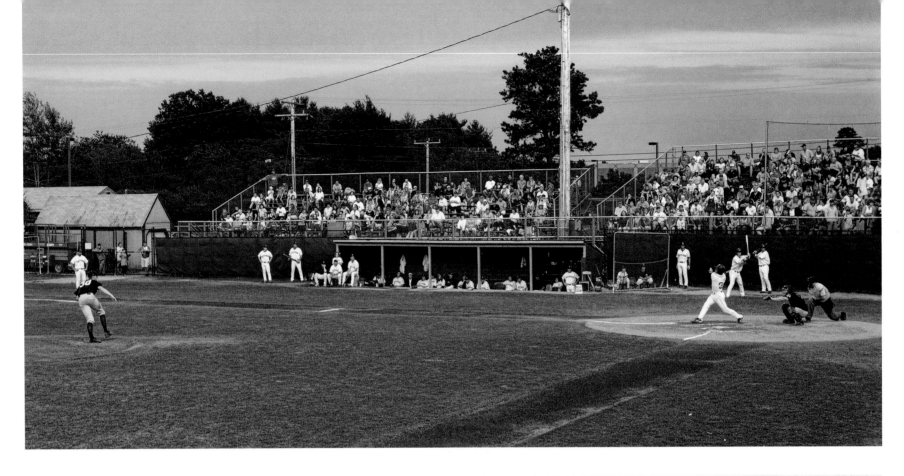

Above: Cape League baseball, Wareham vs. Bourne
Right: Crafts show, Onset campground

A summer tradition, Wareham 23

OLD ROCHESTER

One hundred and sixty years ago Rochester, Marion, and Mattapoisett were all one. Marion and Mattapoisett split off just before the Civil War. Today Rochester remains largely rural, with farms and large fields. Mattapoisett and Marion village centers evoke nostalgia for an unseen era—classic New England churches, true Colonial and Cape Cod homes, and small yards surrounded with white picket fences. Their harbors contain sophisticated cruising and racing sailboats, luxury trawlers, and a few traditional Maine powerboats.

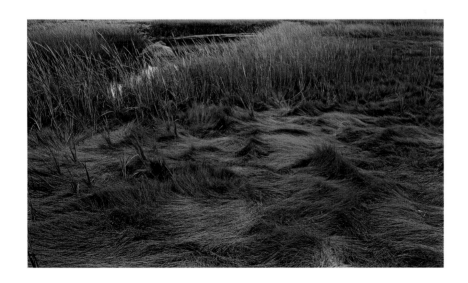

Above: Marsh grass

24 Right: Spring morning, Mattapoisett Harbor

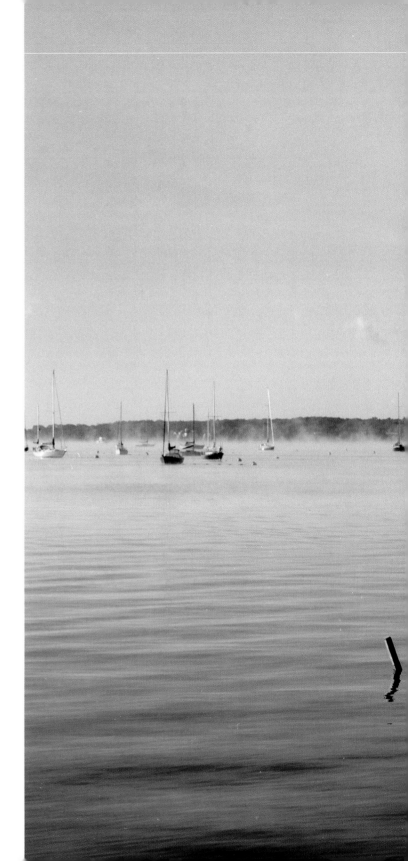

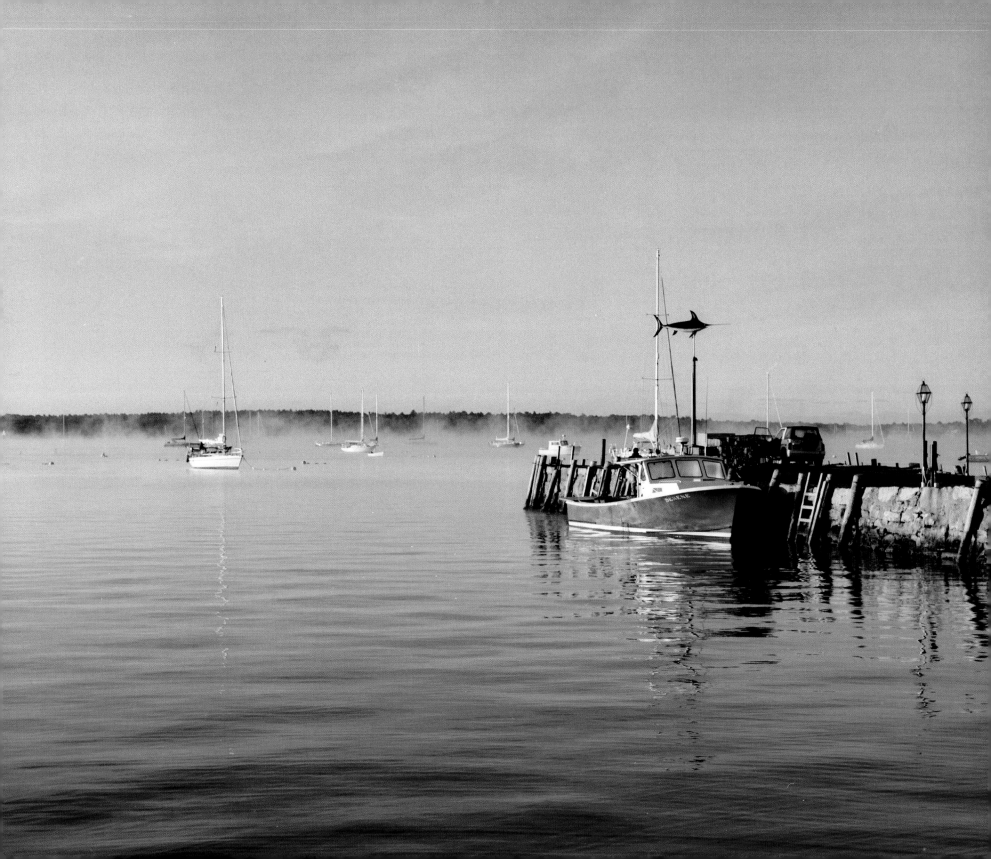

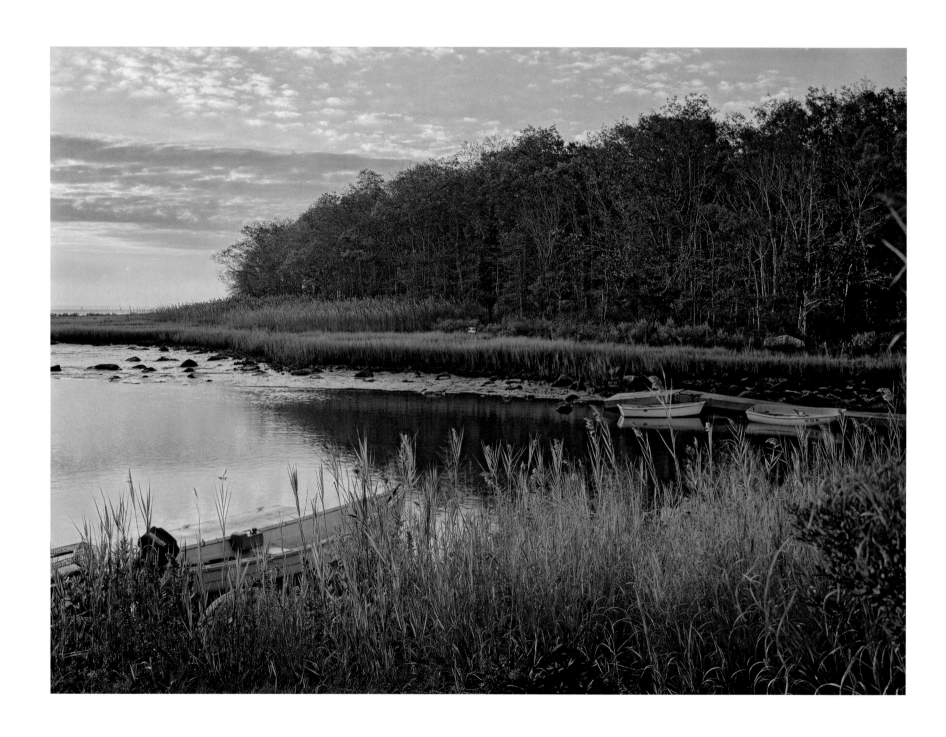

26 Autumn morning, Aucoot Cove

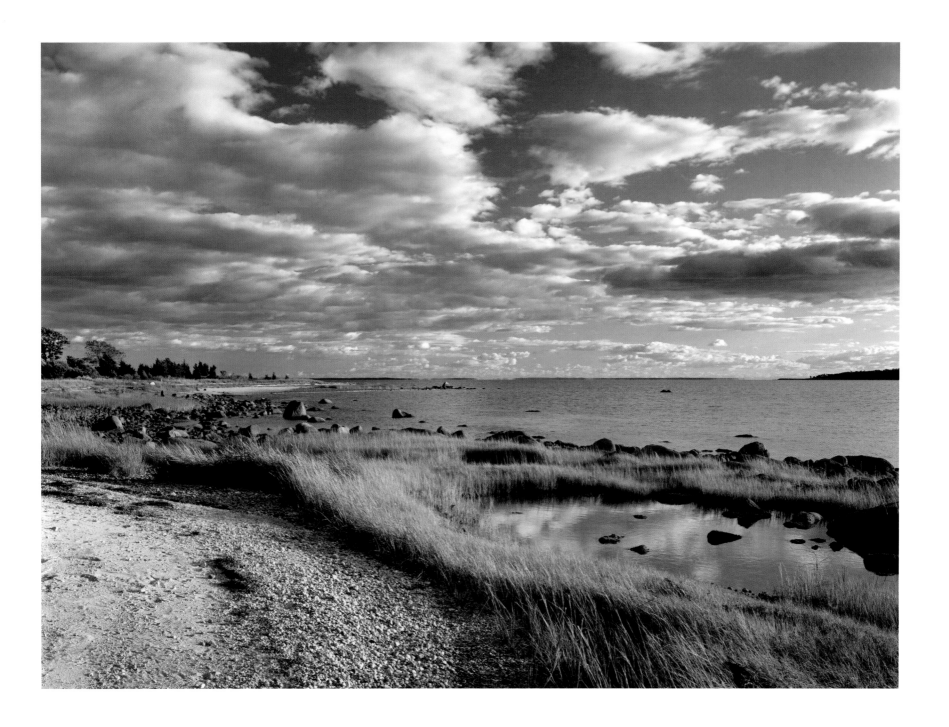

Marion's outer harbor from Planting Island 27

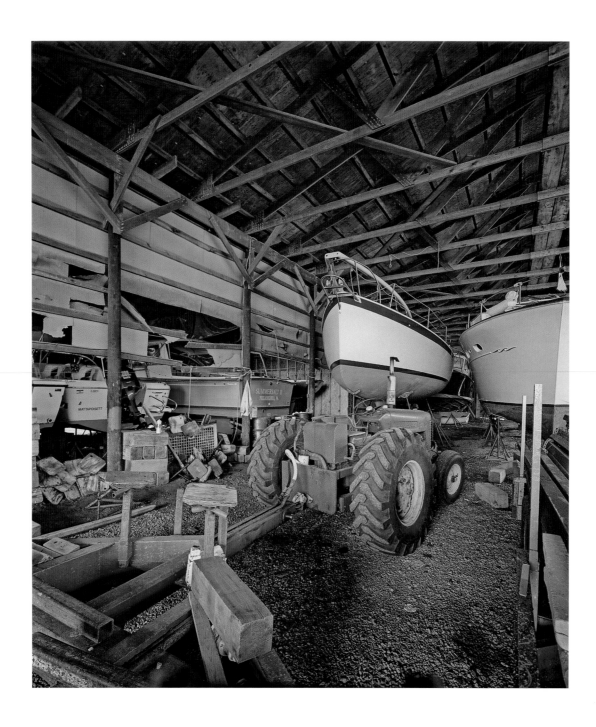

28 Boatyard shed, Mattapoisett

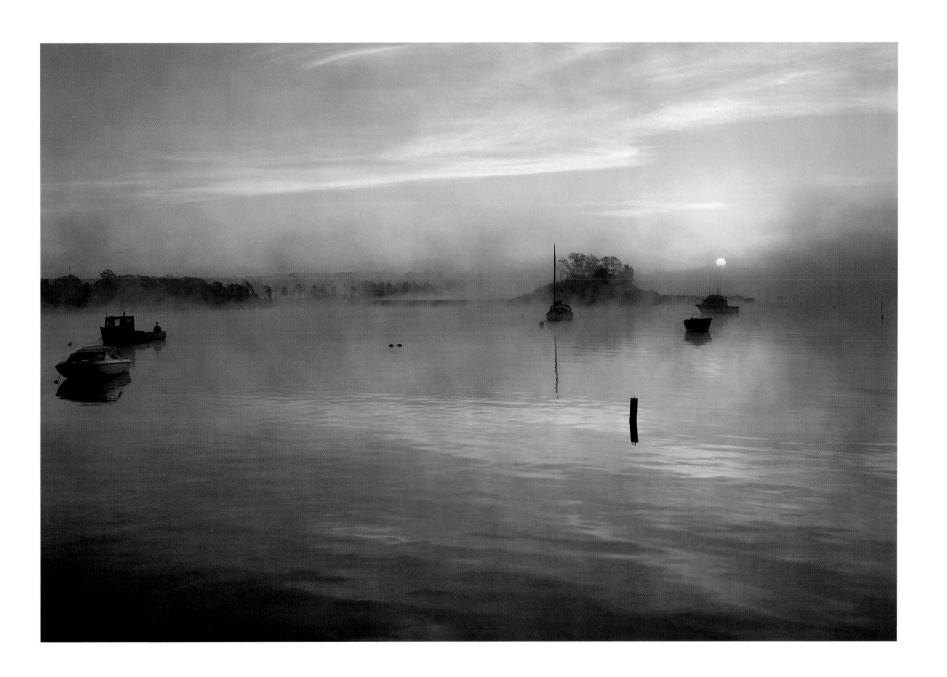

Sunrise at Old Landing, Marion 29

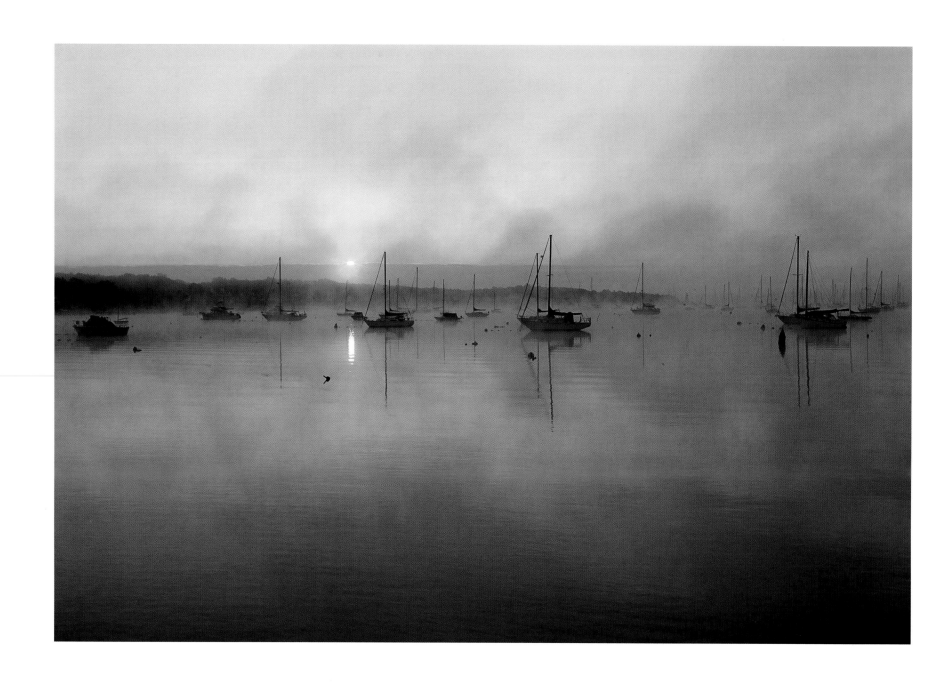

Above: Sunrise with sea smoke, Mattapoisett Harbor

Right: Harbor Days Craft Show, Mattapoisett

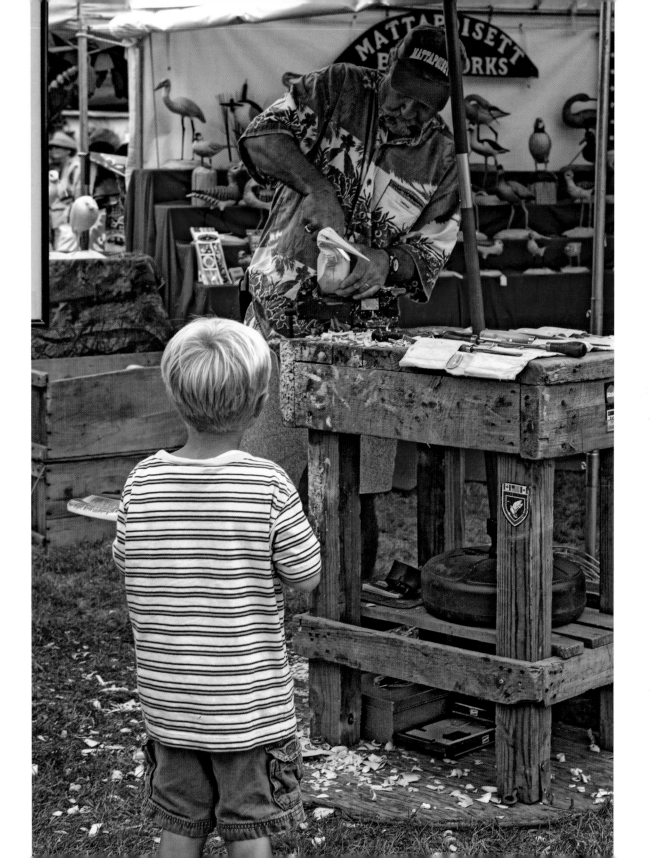

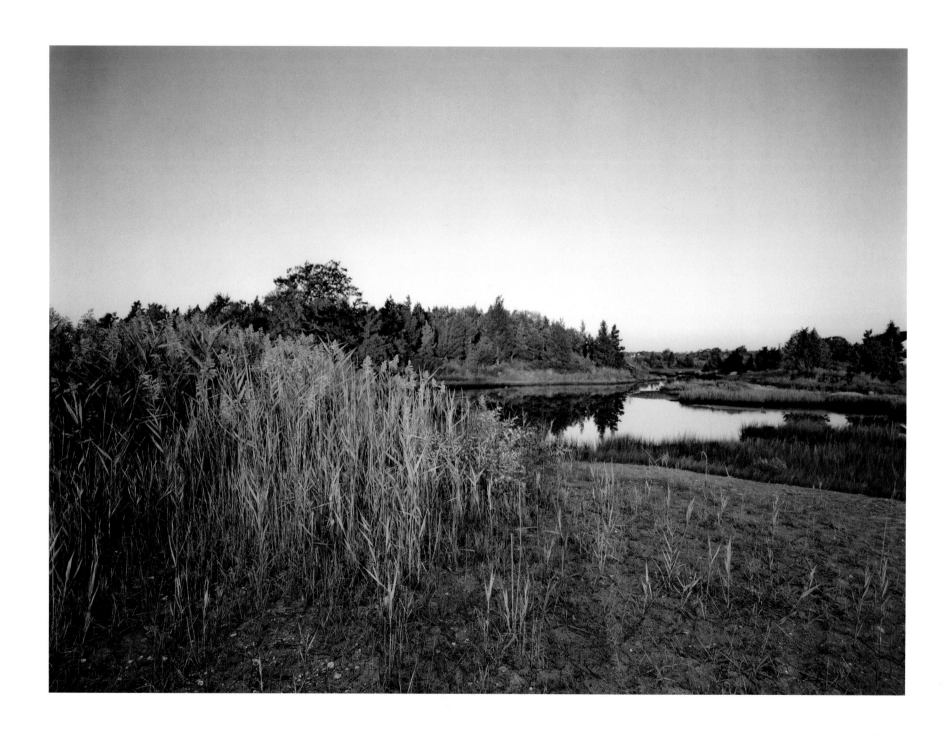

32 Eel Pond Inlet from The Sands, Mattapoisett

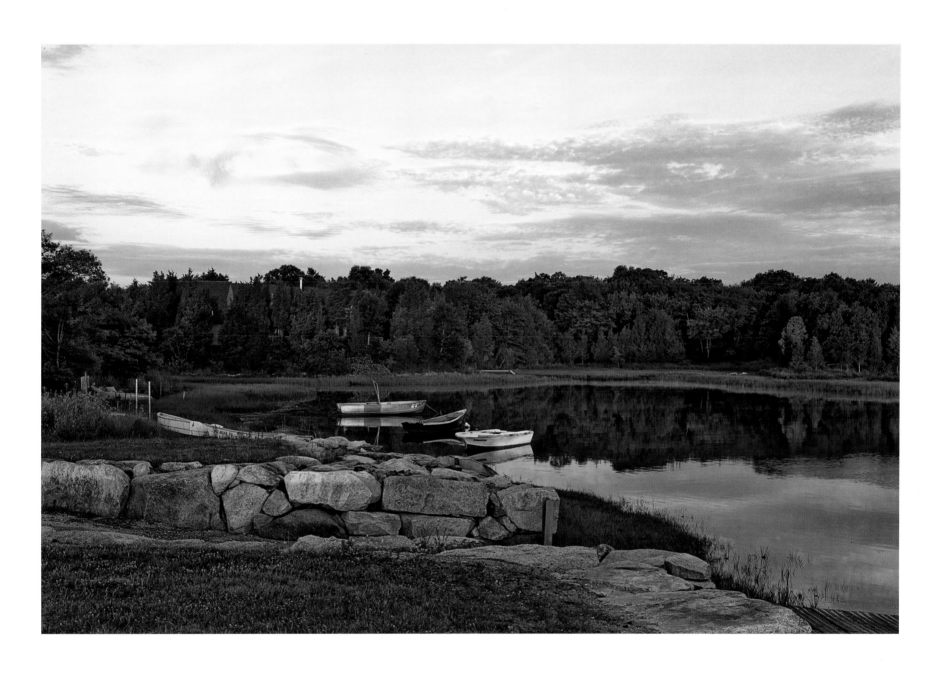

The boat landing on Mattapoisett Neck

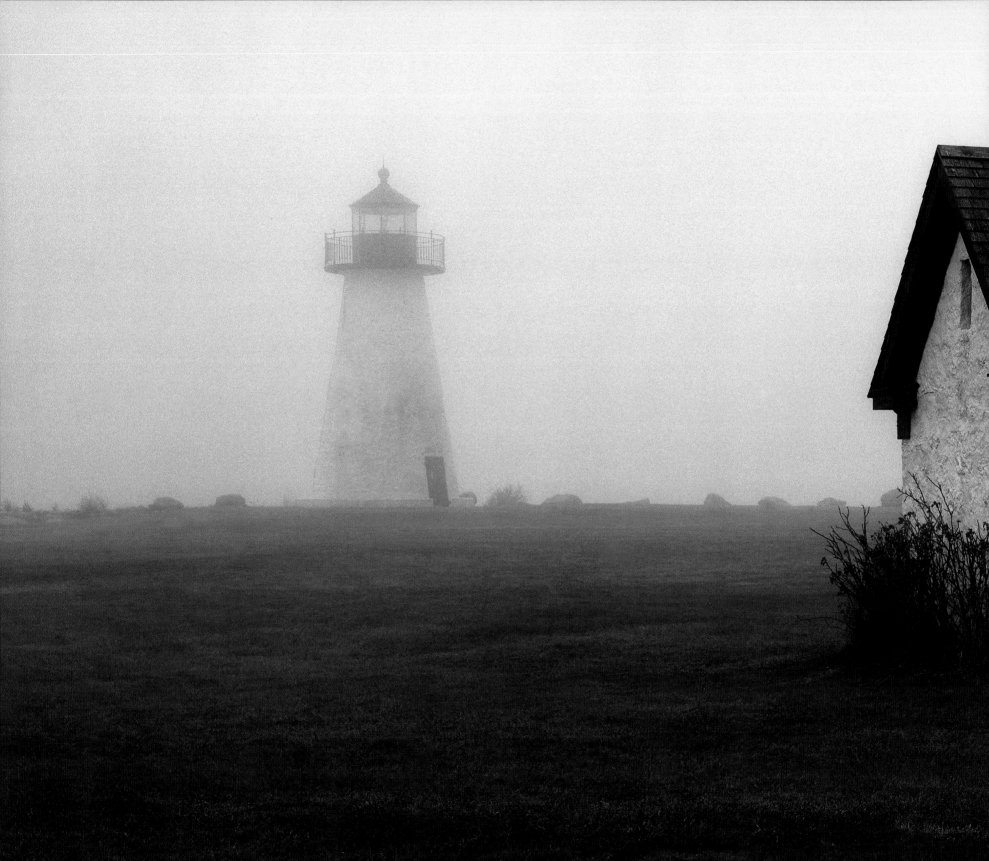

Ned's Point Light and its
oil house, Mattapoisett

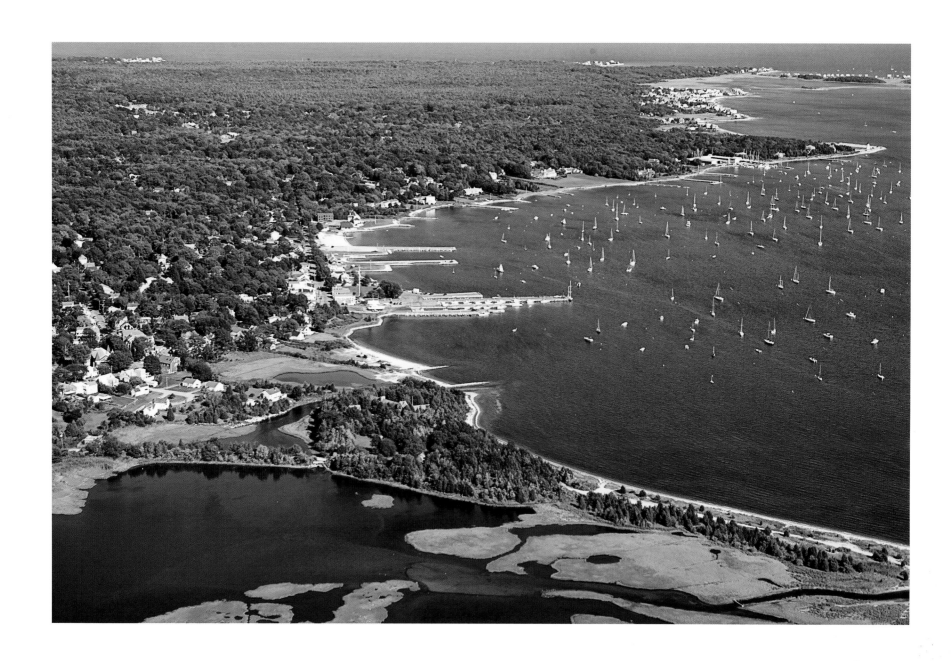

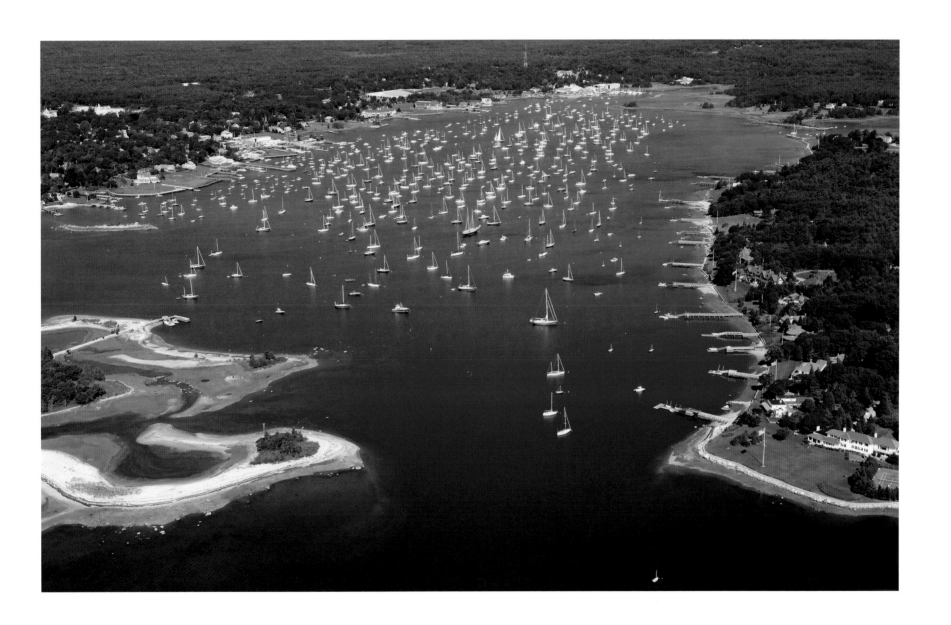

Sippican Harbor, Marion, with Ram Island on left 37

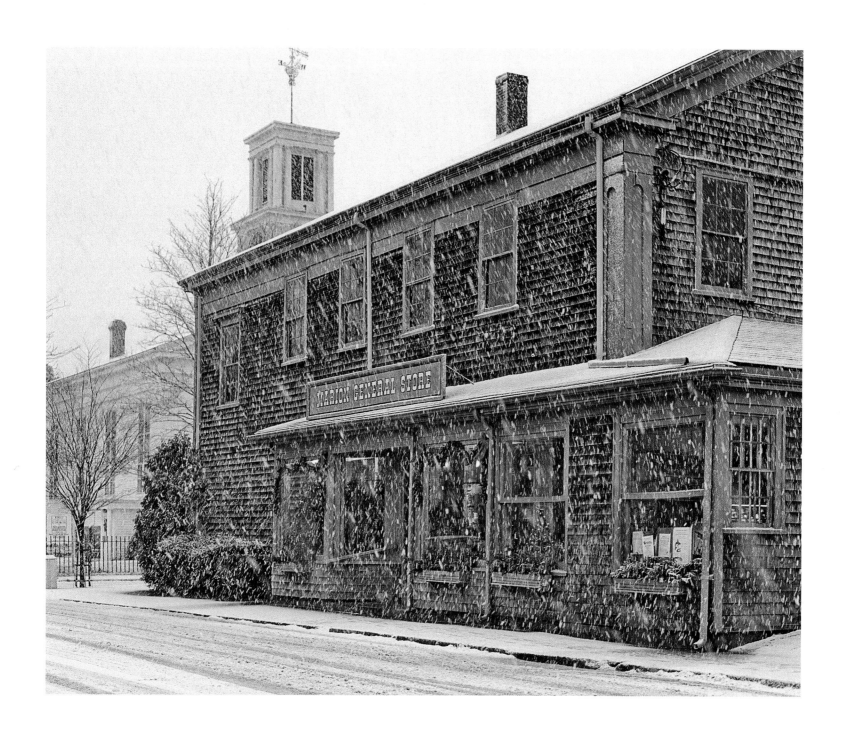

Marion General Store at Christmas

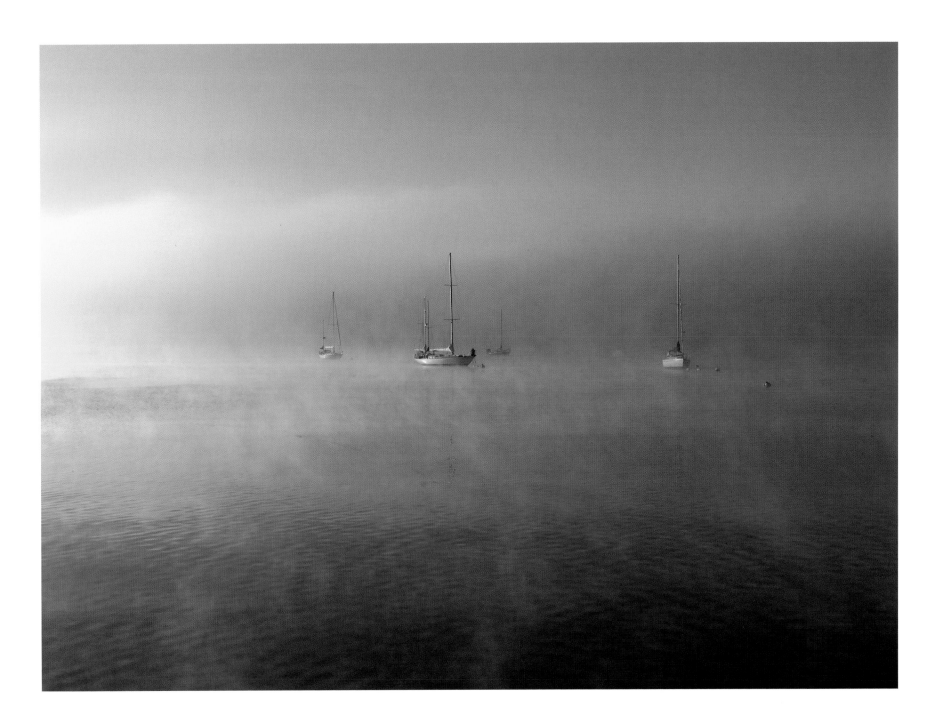

40 Ice cream shack on the wharf, Mattapoisett

July 4th parade, Marion 41

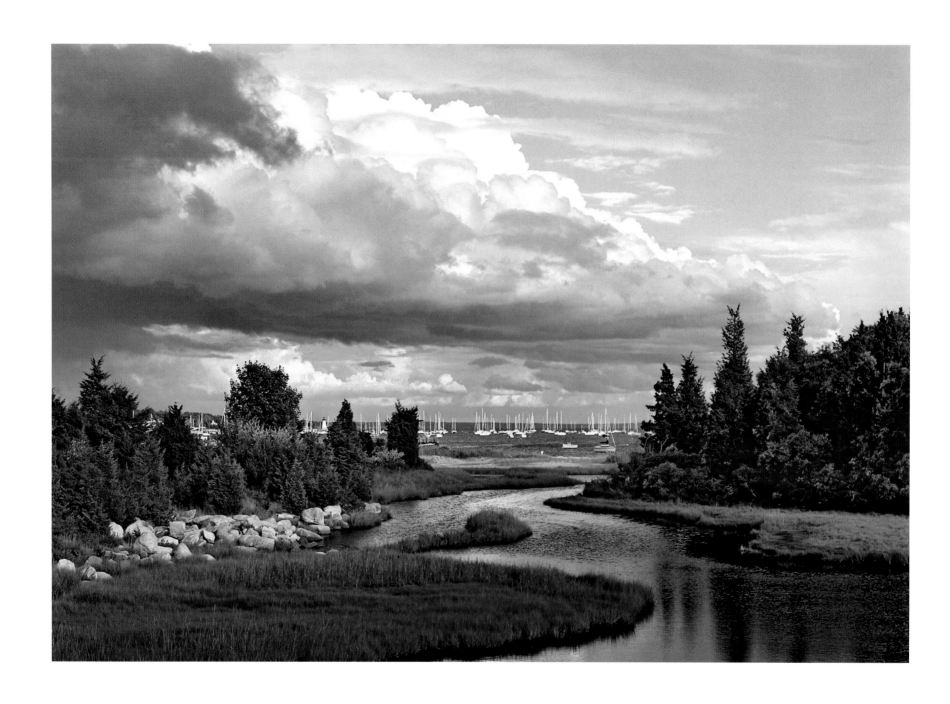

42 Eel Pond inlet, Mattapoisett

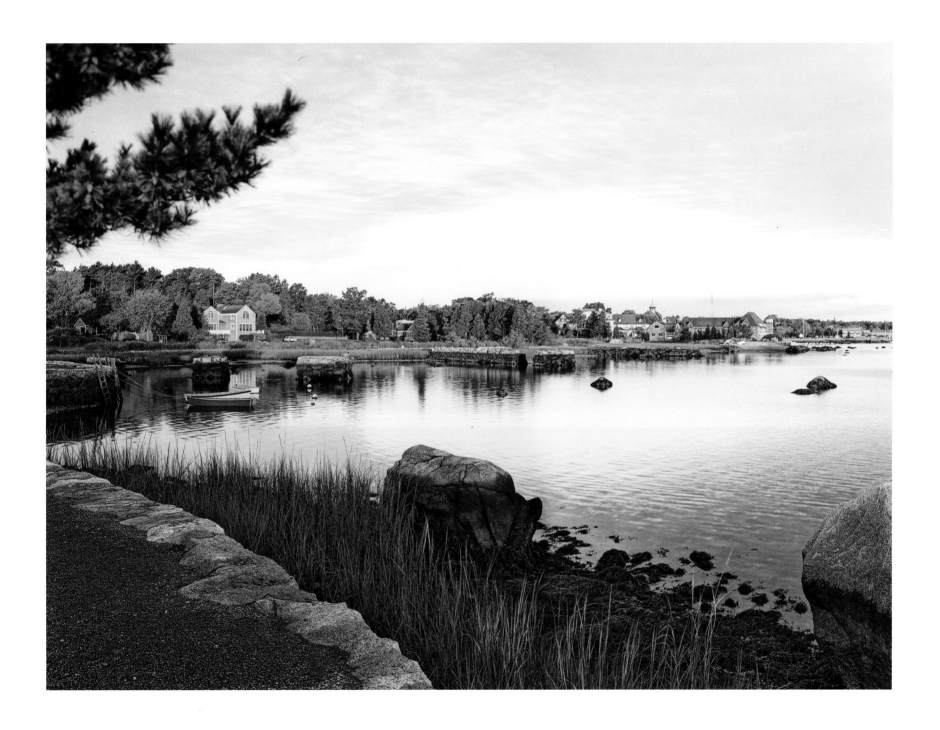

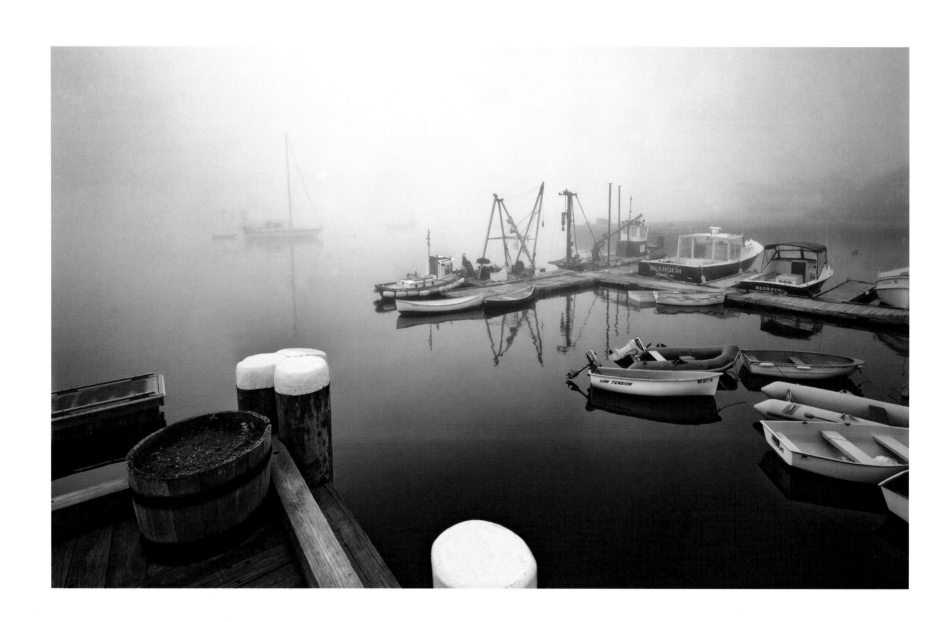

44 Island Wharf and Barden's dinghy dock, Marion Village

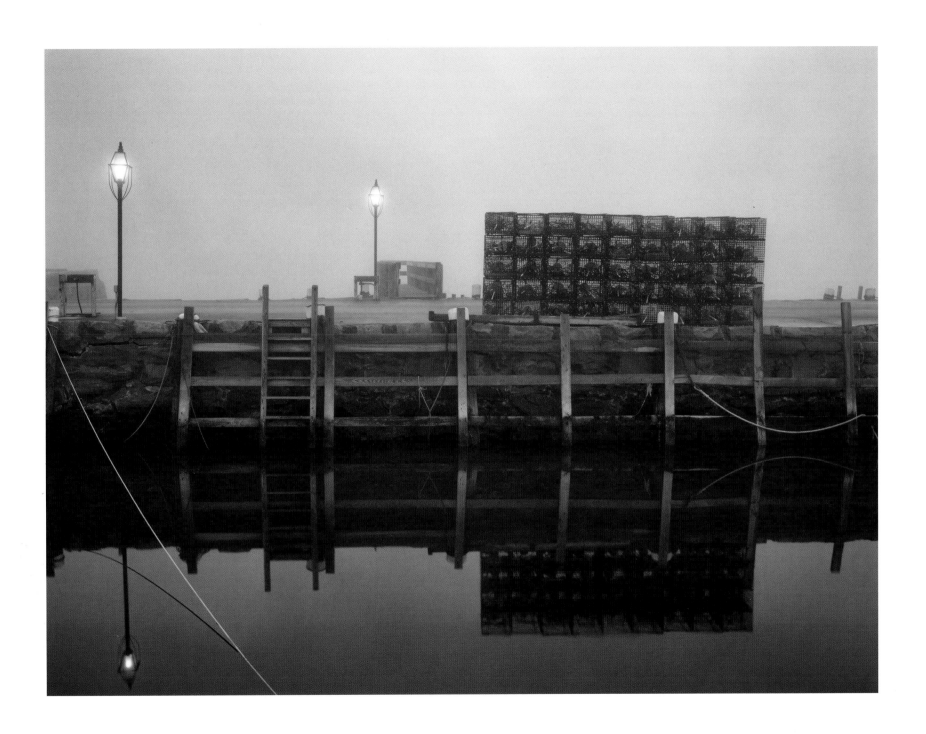

Lobster traps on town wharf, Mattapoisett 45

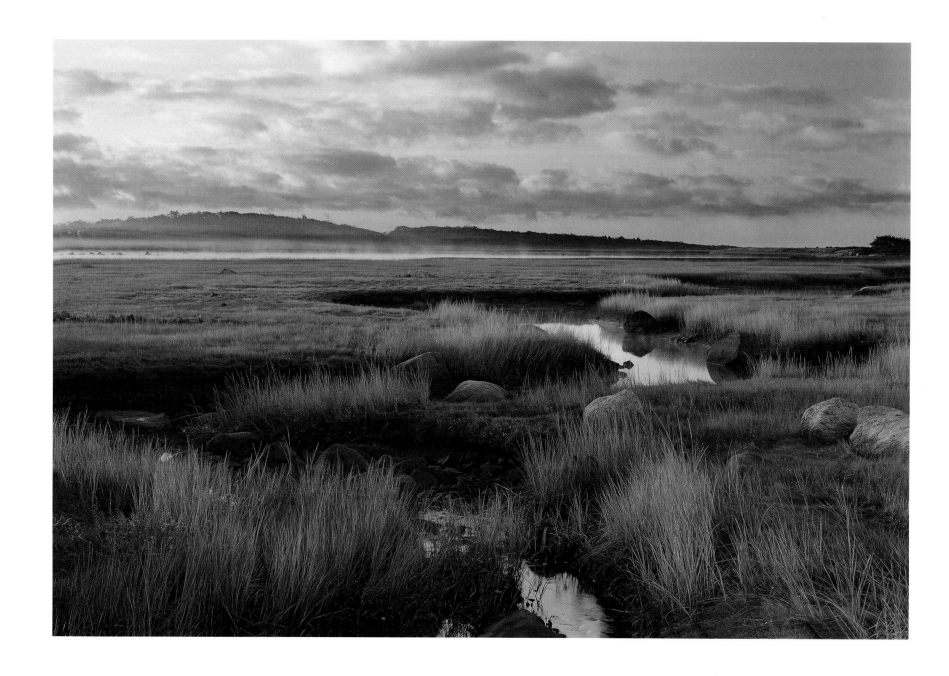

46 Pine Island Marsh, Mattapoisett

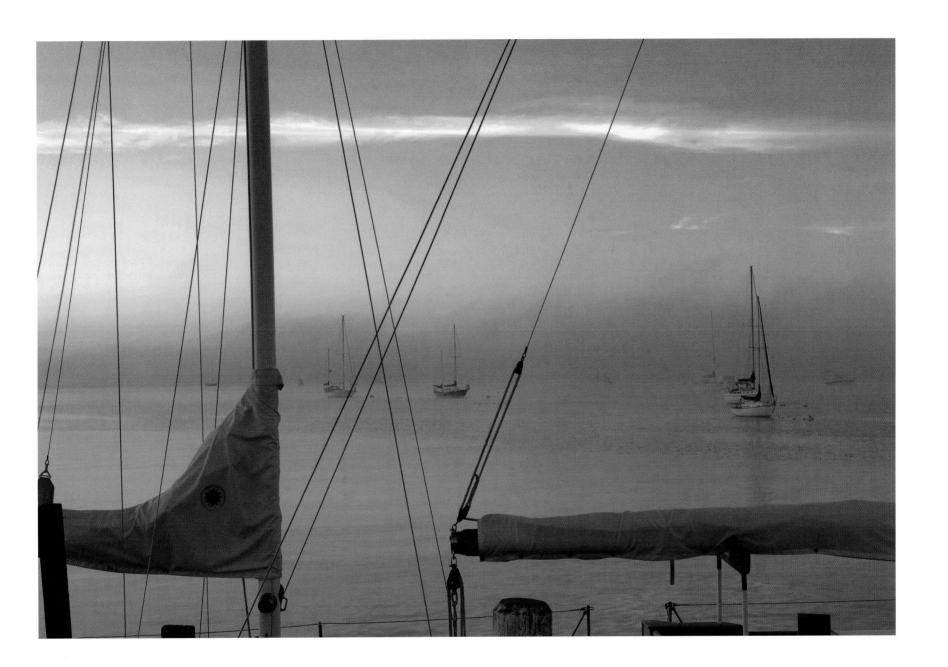

Mattapoisett Harbor, through *Saudade*'s rigging 47

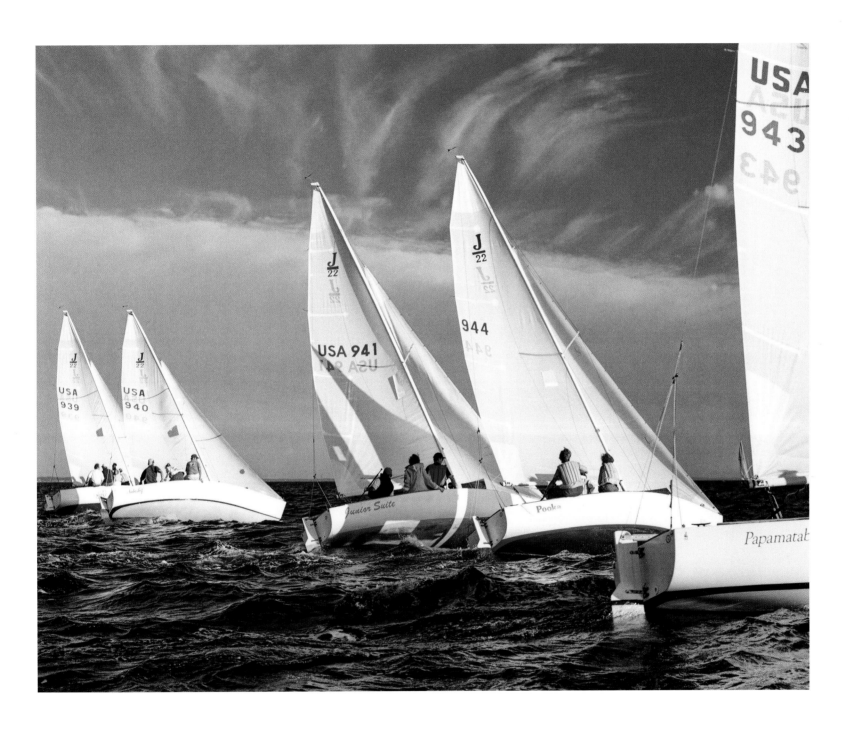

Above: Club racing, J-22's
Left: *Tabor Boy*, Tabor Academy's schoolship 49

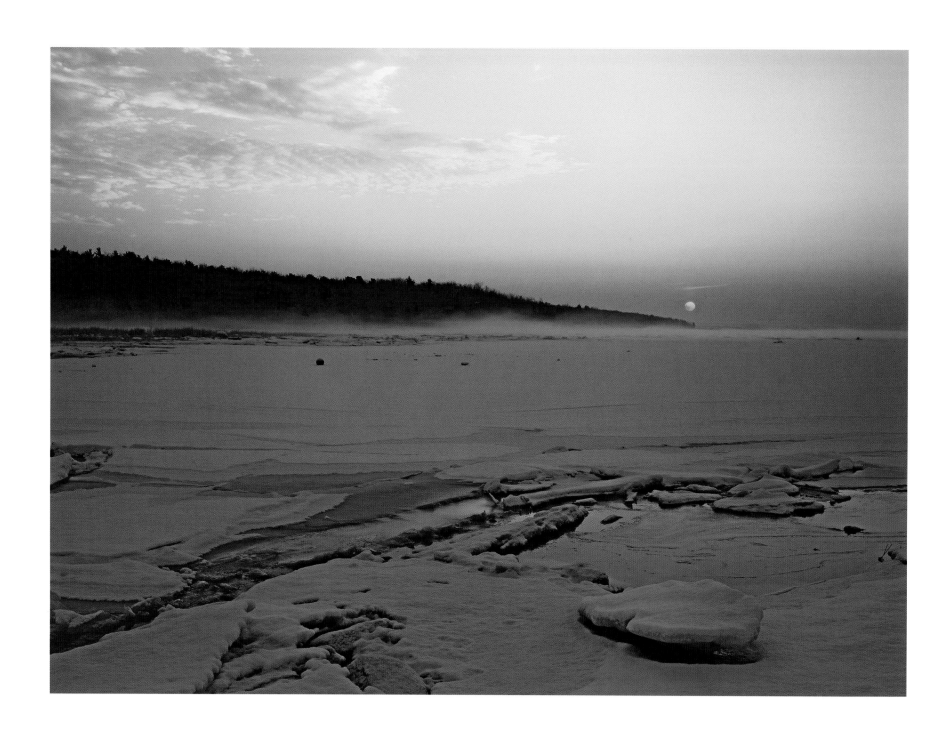

50 January sunrise in Wings Cove, East Marion

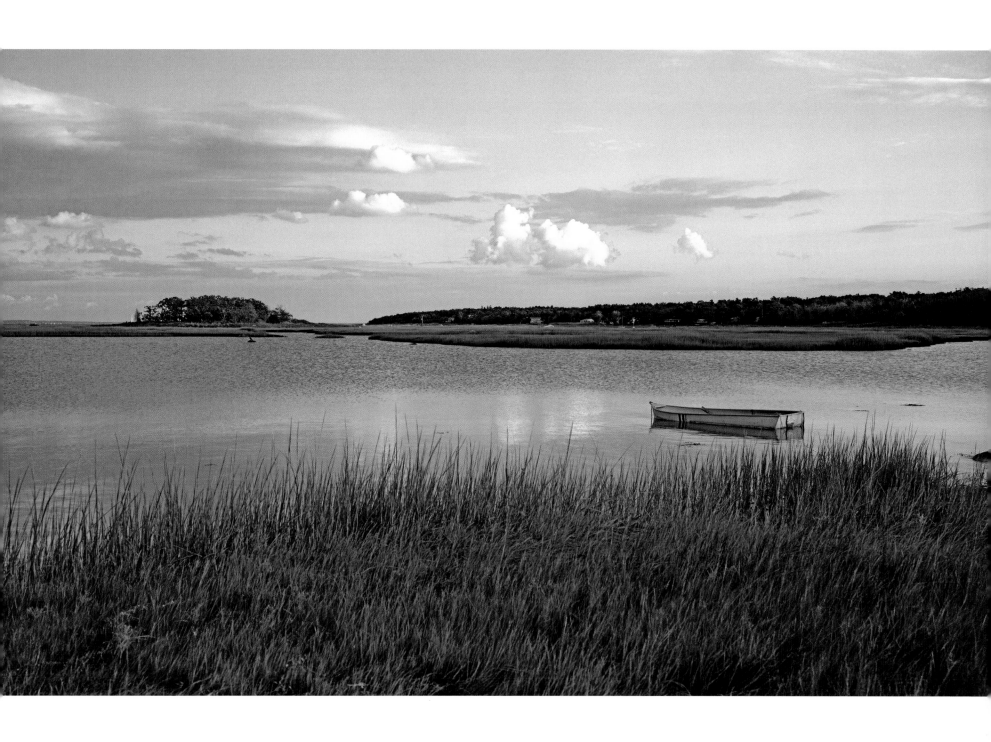

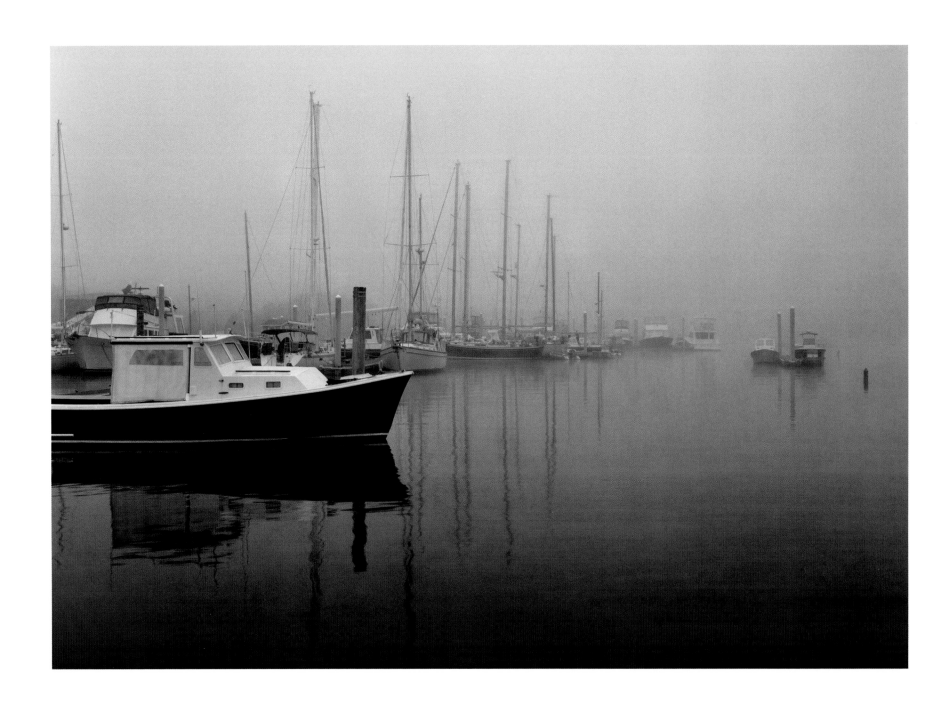

52 The boatyard at Old Landing, Marion

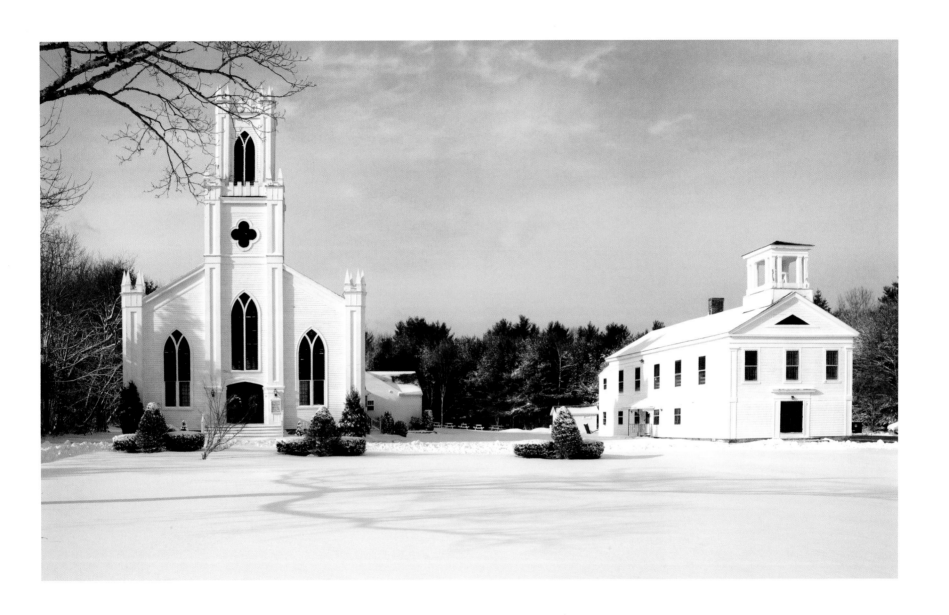

Rochester Congregational Church and its vestry 53

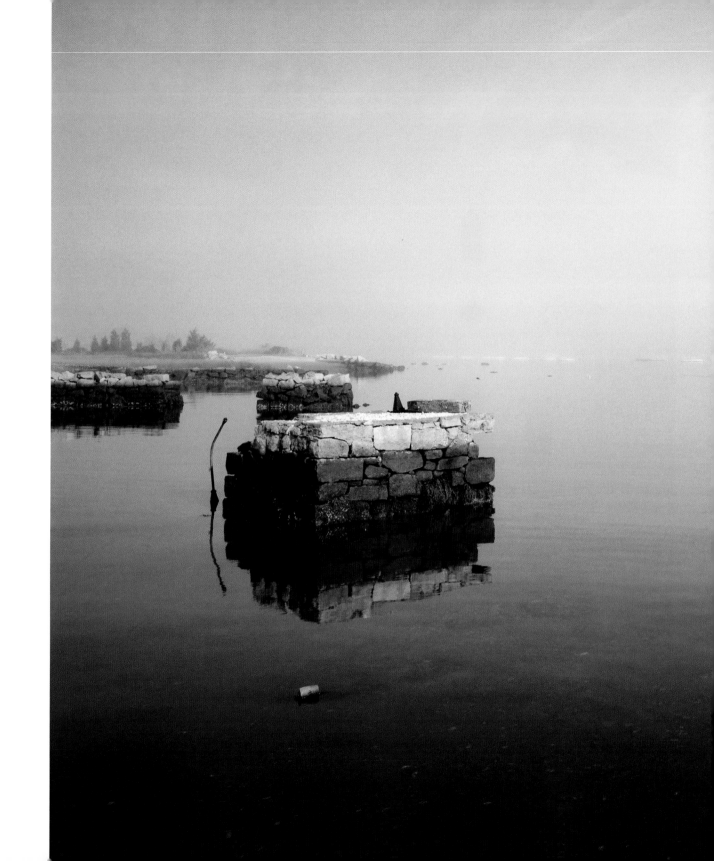

Bill's boat,
Sippican Harbor, Marion

54

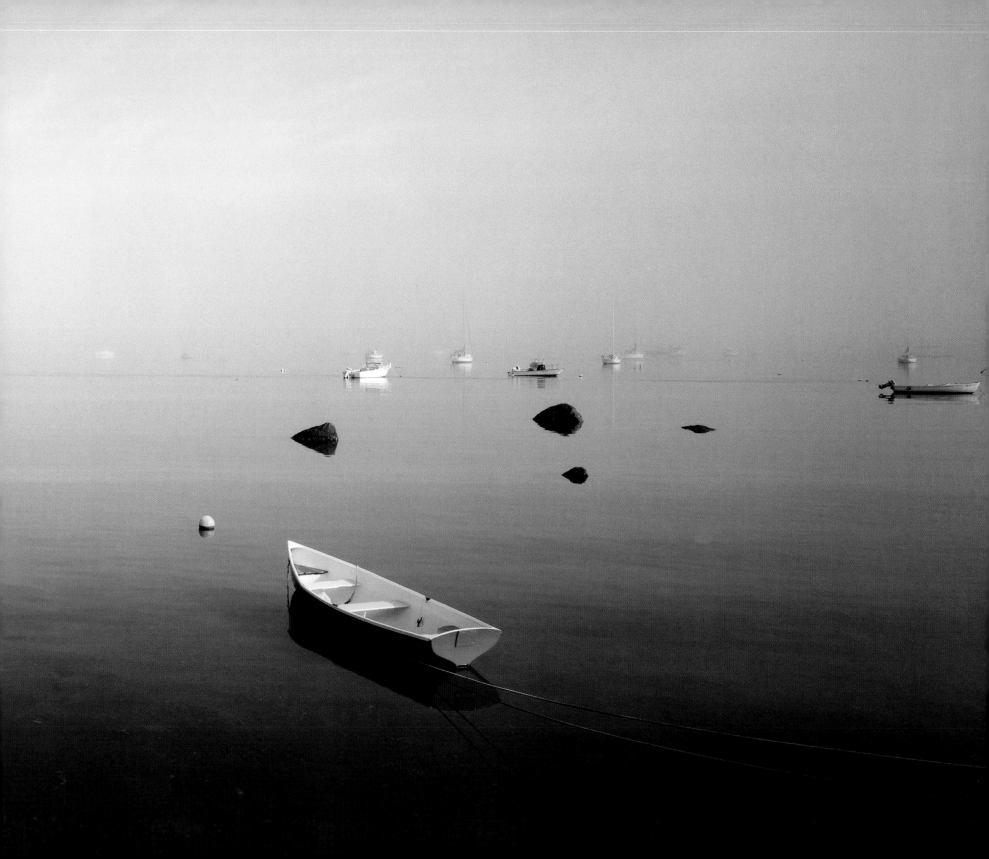

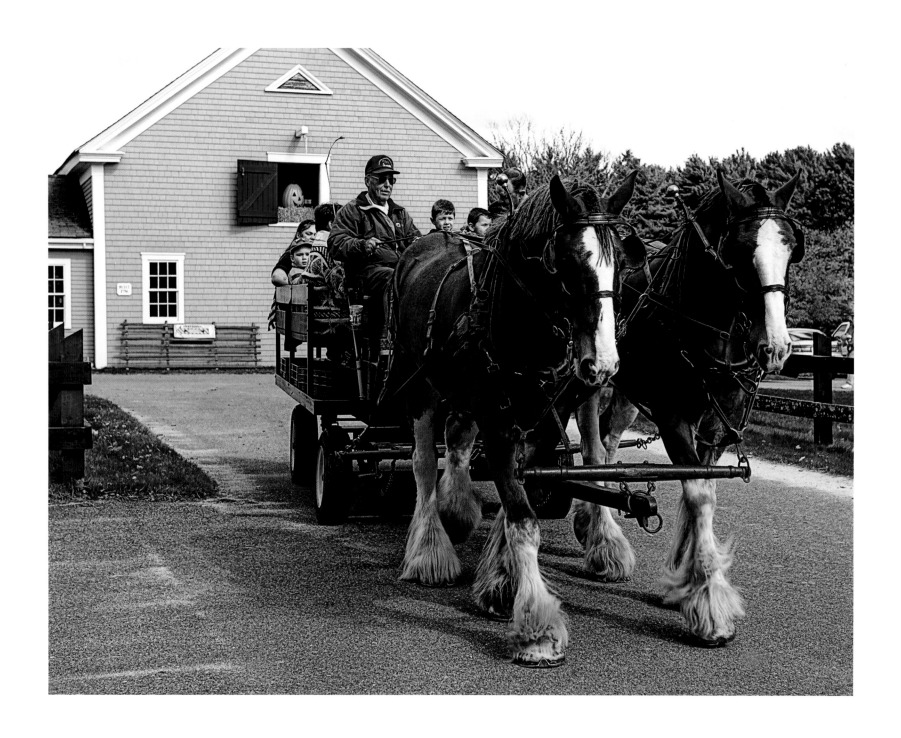

56 Autumn ride with Clydesdales at Eastover Farm, Rochester

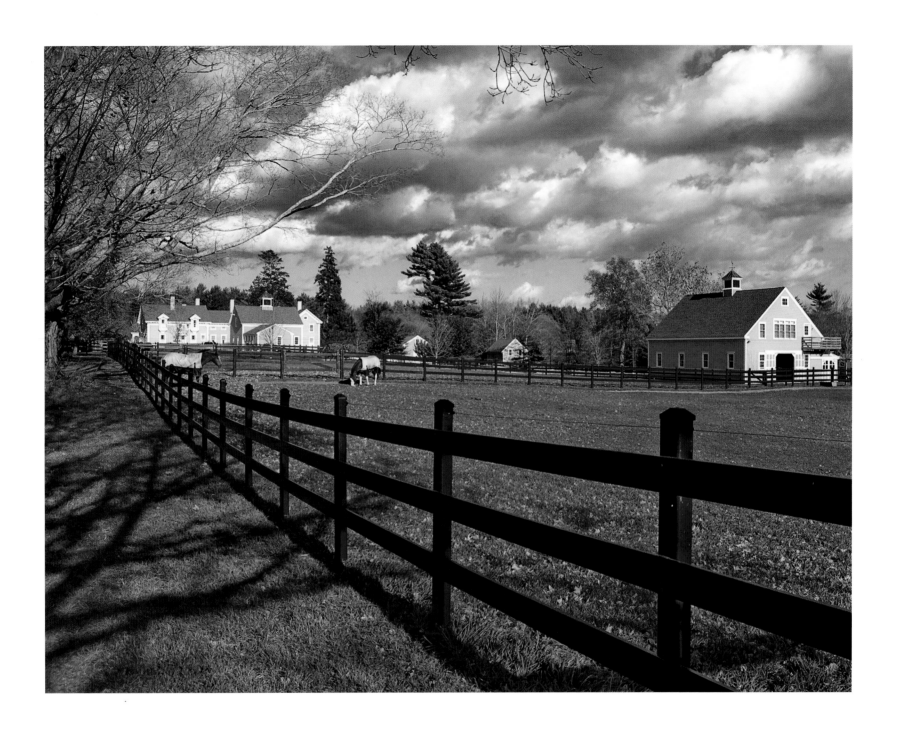

Pasture at Eastover Farm, Rochester 57

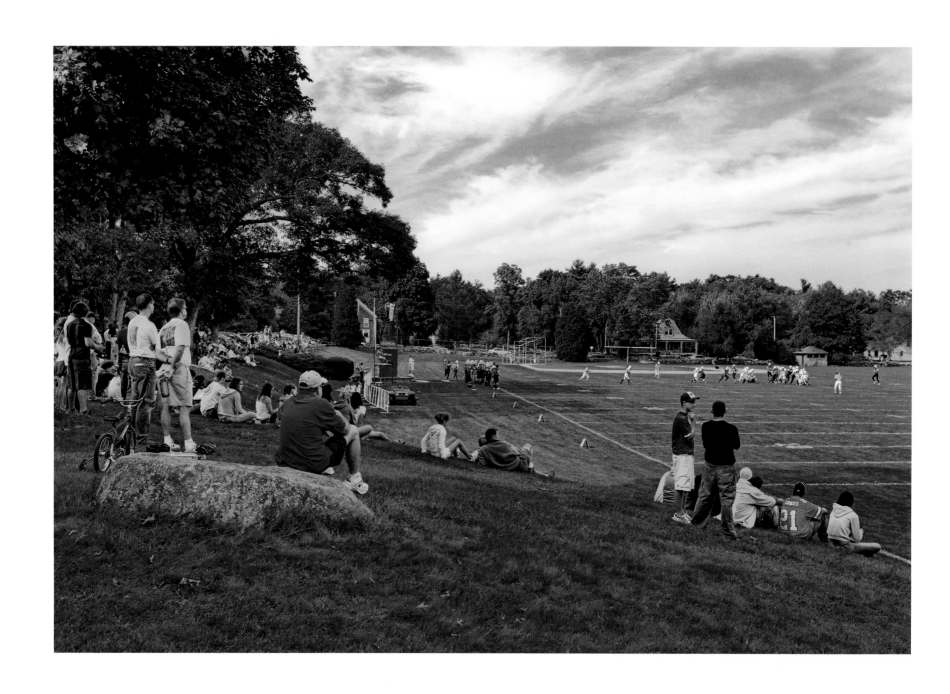

Above: Saturday football at Tabor Academy, Marion

Right: Congregational Church Summer Fair, Marion. The church dates from 1841.

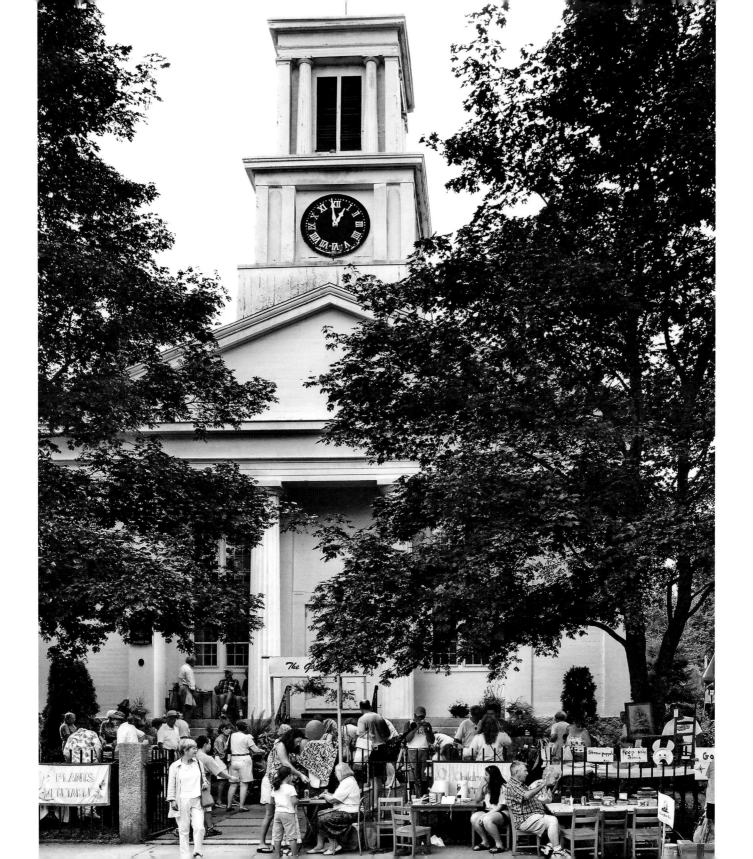

60 The gazebo in Shipyard Park, Mattapoisett

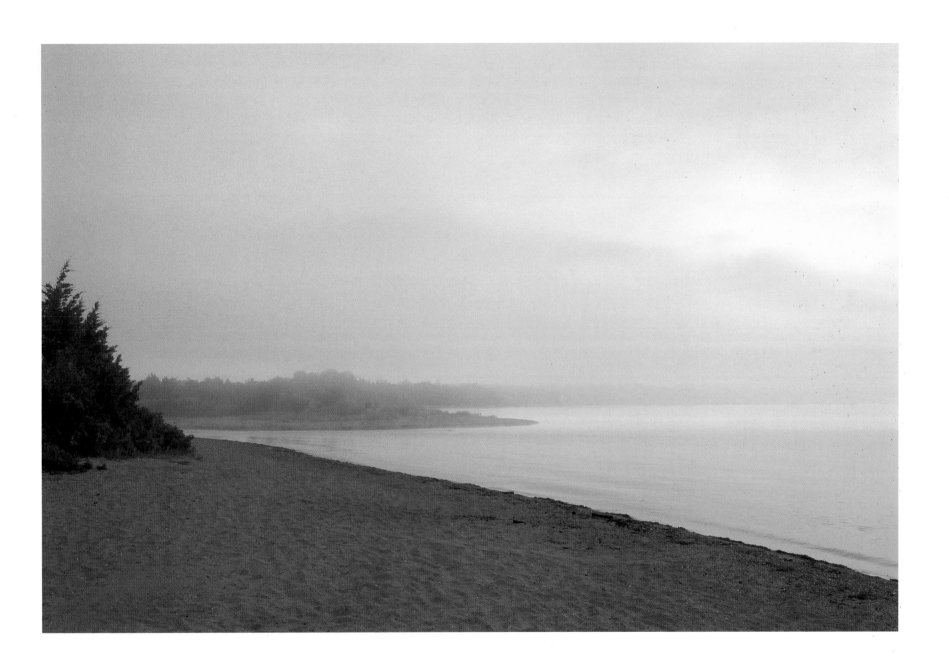

Dawn at Shining Tides, Mattapoisett 61

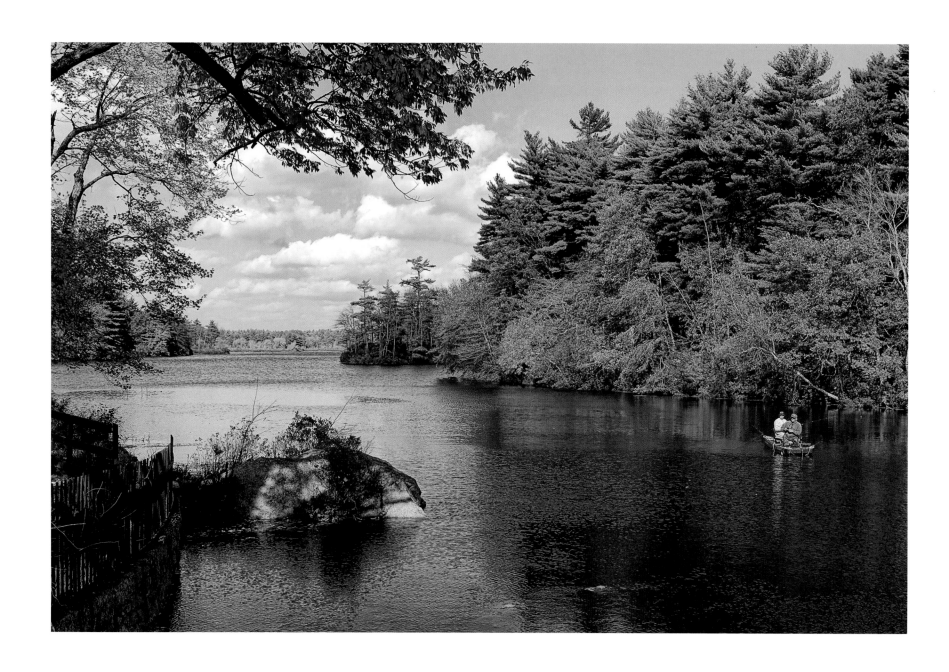

62 Leonard's Pond, Rochester

Main Street, Marion 63

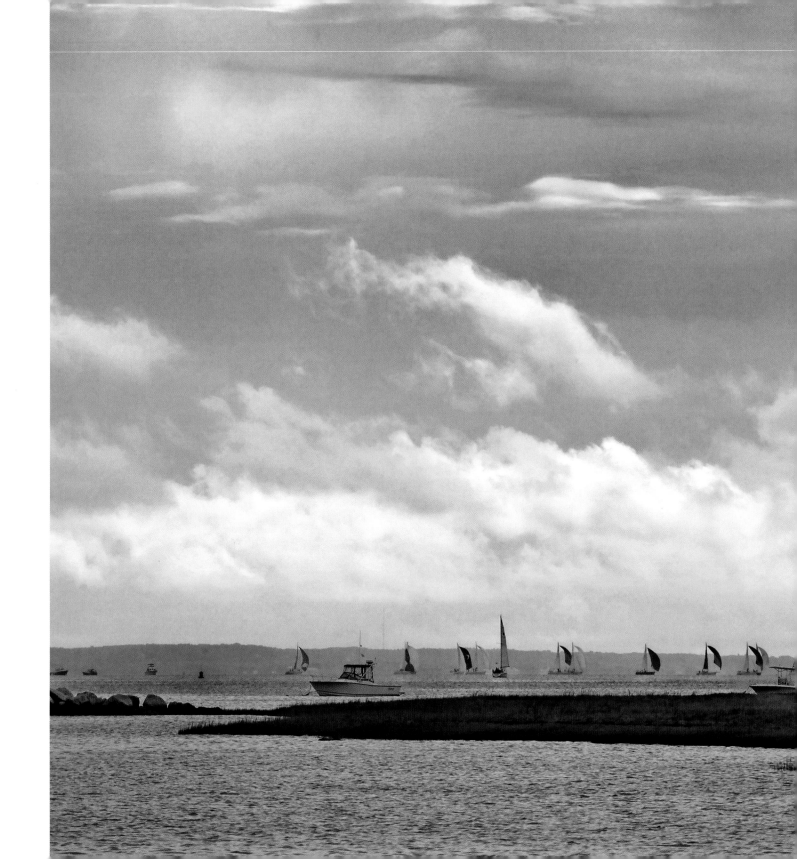

J-105 regatta,
Buzzards Bay

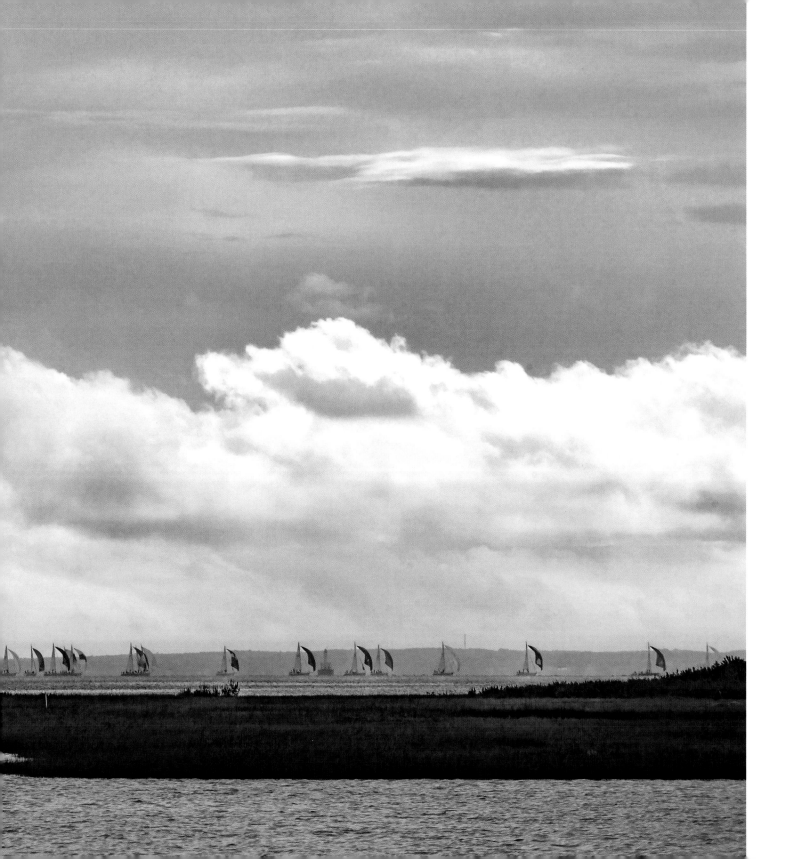

WORKING HARBOR

New Bedford and Fairhaven straddle a busy fishing port, with Acushnet adding a bit of rural character. Fairhaven's boatyards work on everything nautical from a *Mayflower* replica to ocean cruisers from Europe. Large homes with cupolas suggest Fairhaven's and New Bedford's status during the nineteenth century. Today New Bedford's working waterfront retains the character of whaling days, with cobblestone streets and granite whale-oil warehouses converted to small shops. As a New York visitor put it, "This isn't one of your cappuccino fishermen's wharves—this is the real thing."

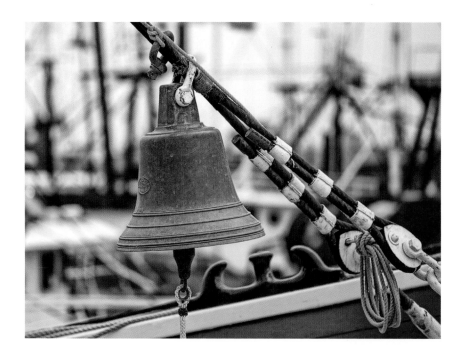

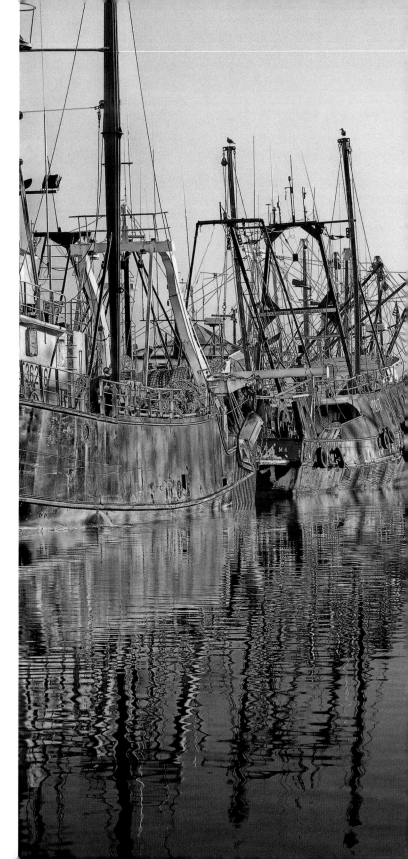

Above: Ship's bell, *Gazela*

Right: Coalpocket Pier, New Bedford

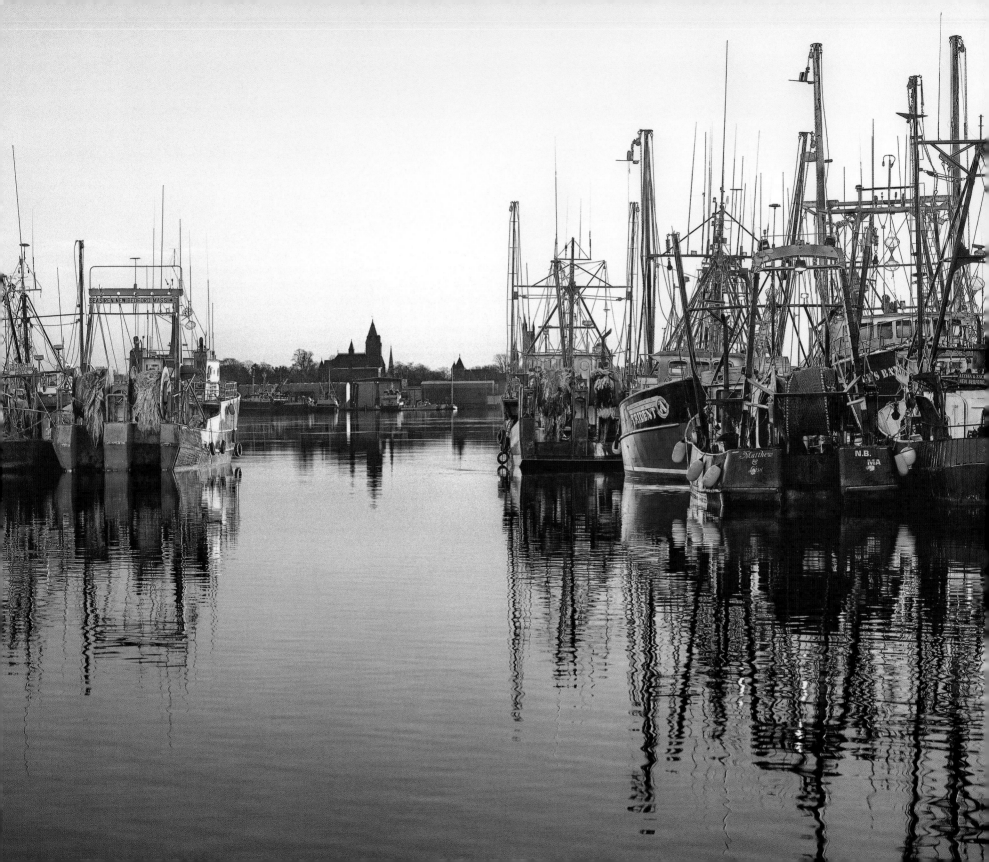

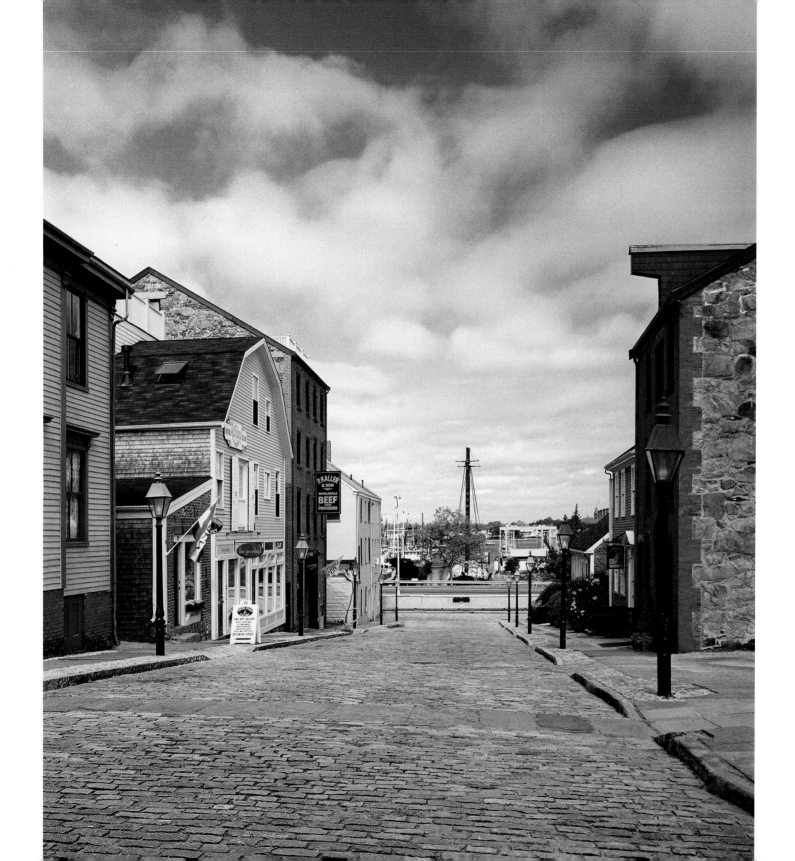

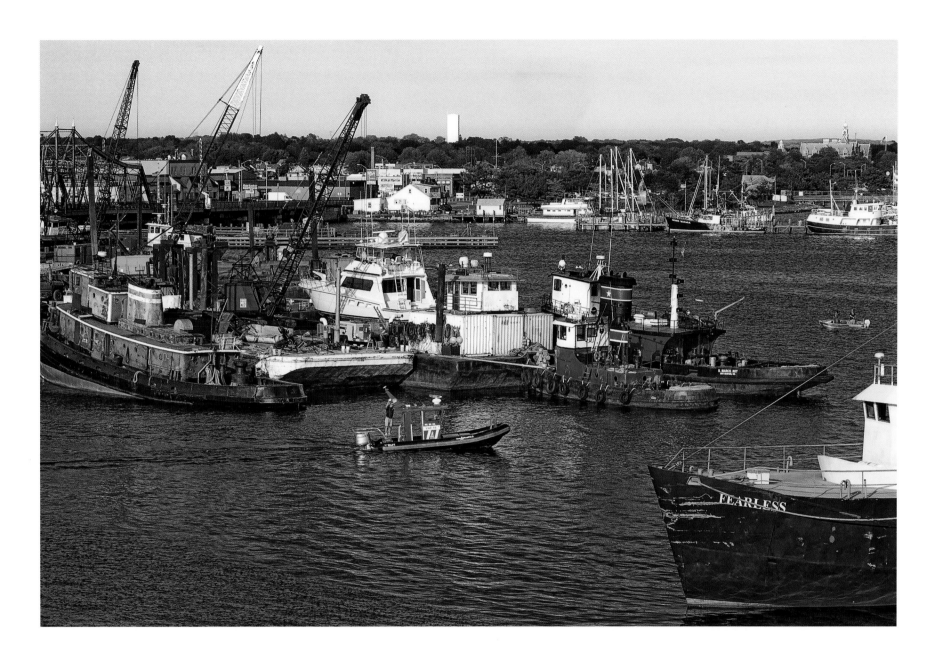

Above: Working boats, New Bedford Harbor

Left: Centre Street, New Bedford Whaling National Historical Park. This street is said to be New Bedford's oldest. 69

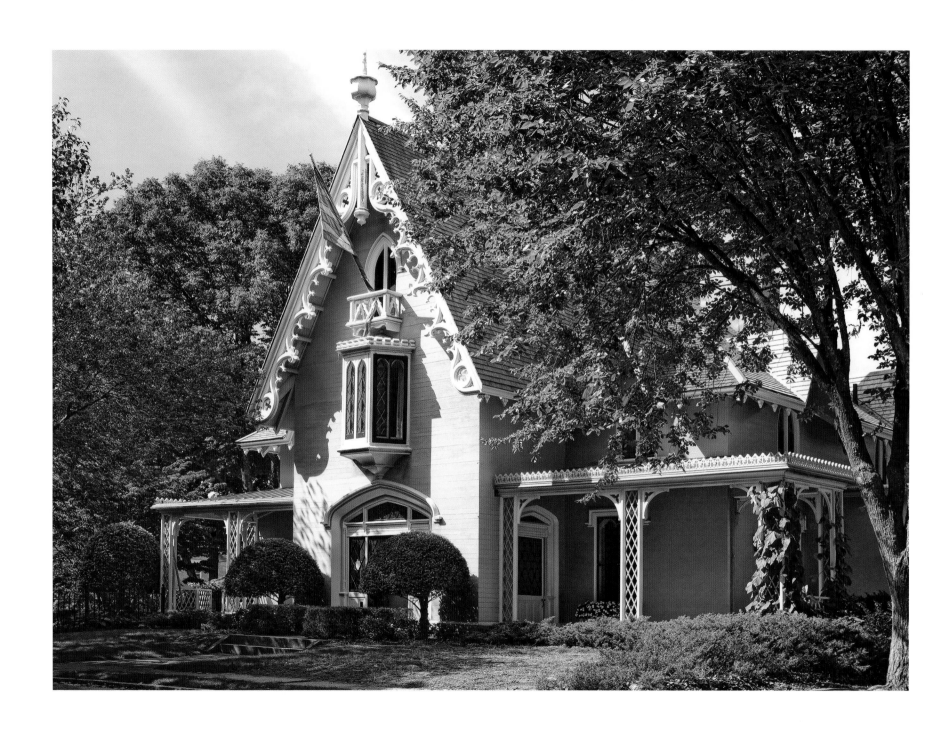

70 William J. Rotch House, New Bedford. The present owner is the great-great-great-great-grandson of the original owner.

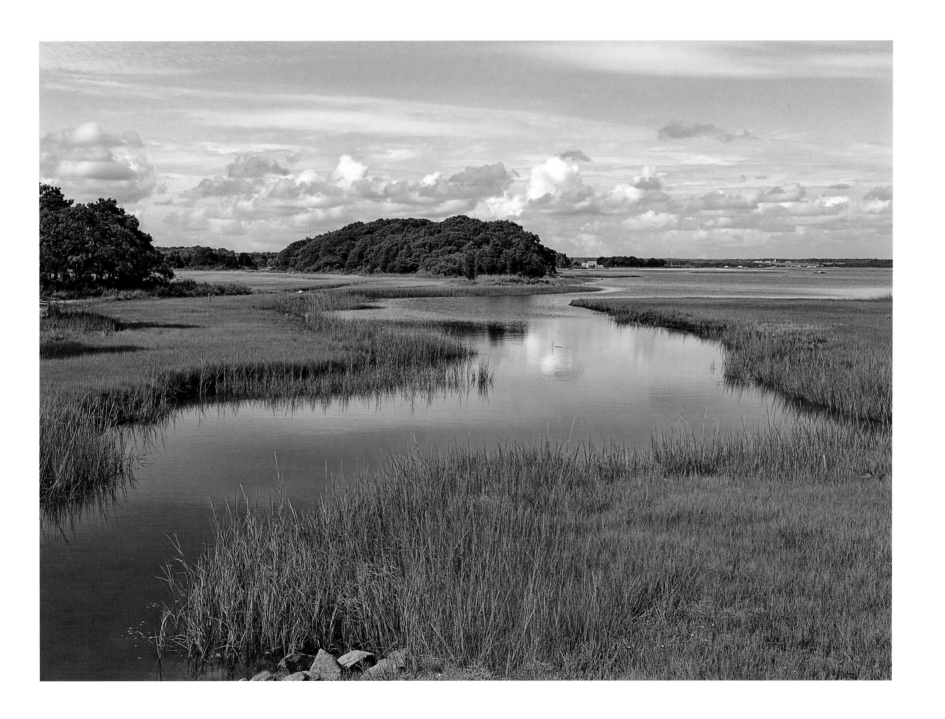

Tidal stream, Sconticut Neck, Fairhaven, with Nasketucket Bay in background 71

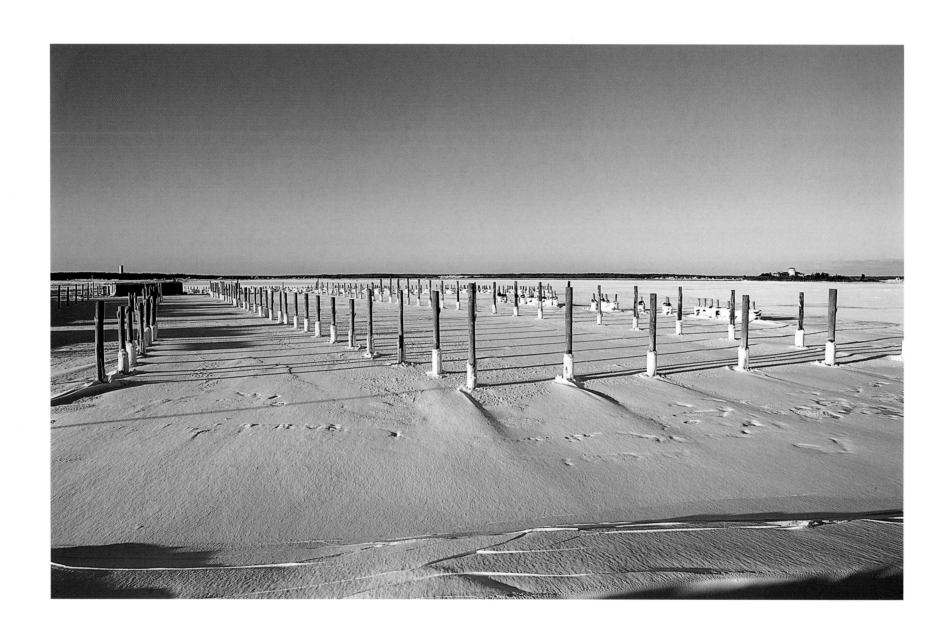

72 Snowbound marina, West Island, Fairhaven

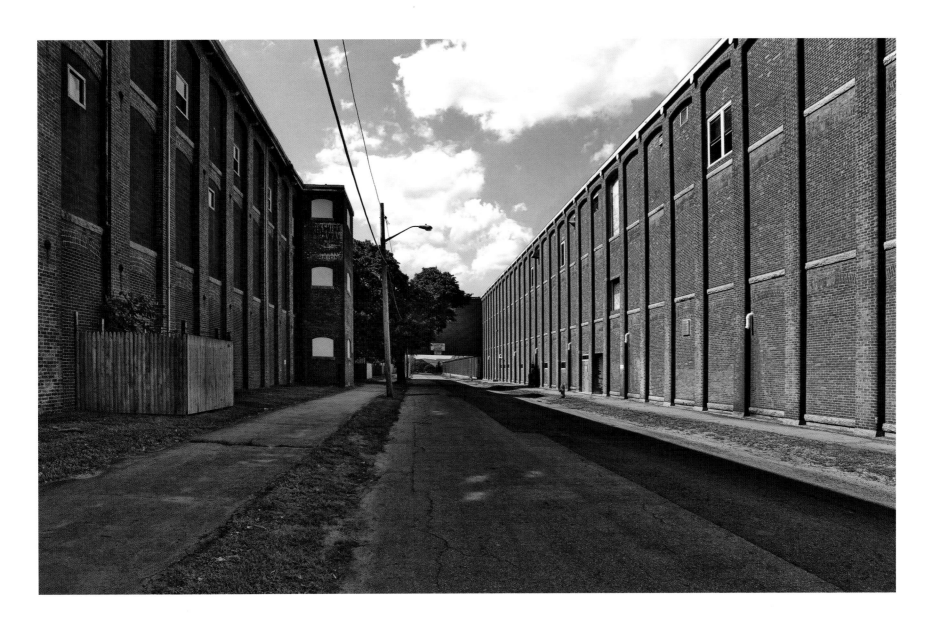

Deserted Berkshire-Hathaway mills, New Bedford 73

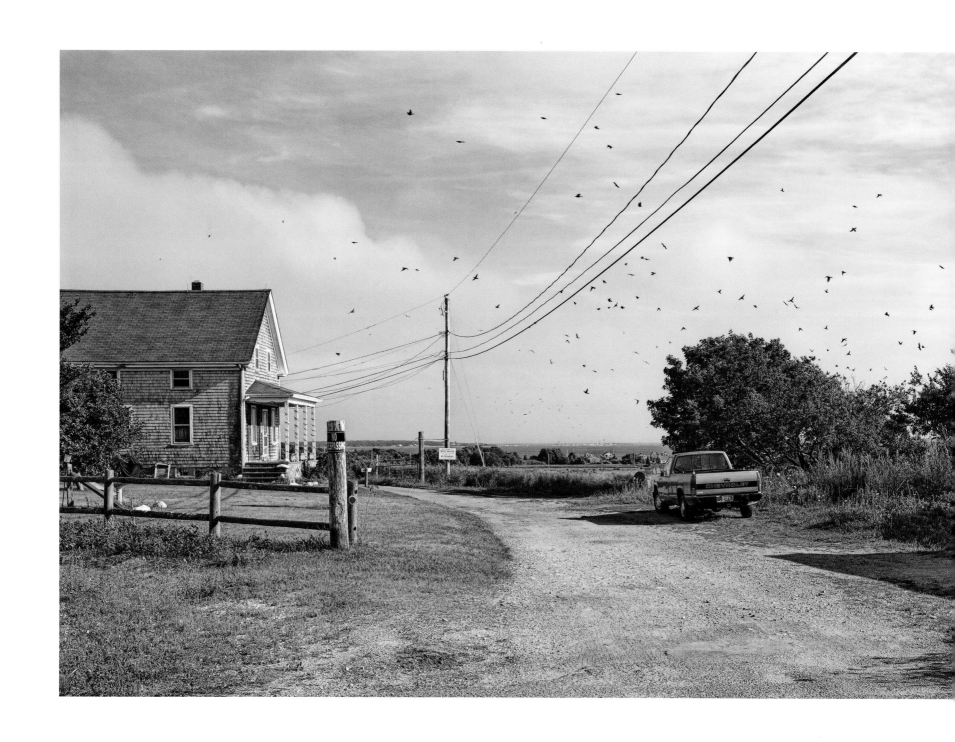

74 Saltwater farm overlooking Nasketucket Bay, Fairhaven

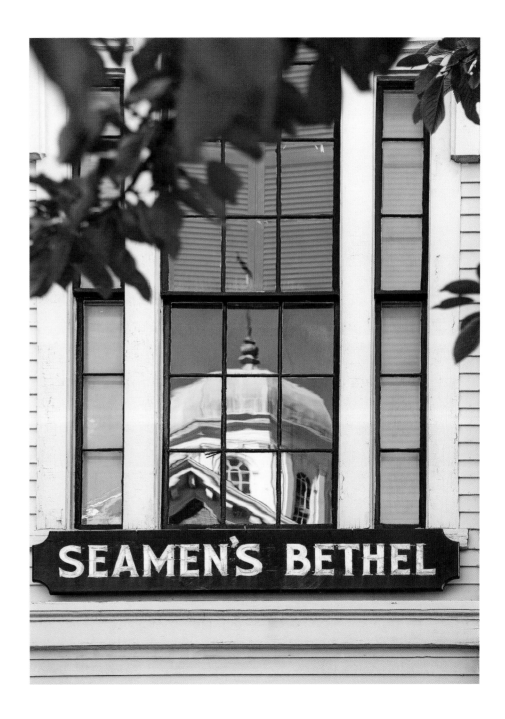

Whaling Museum cupola, reflected in Seamen's Bethel window 75

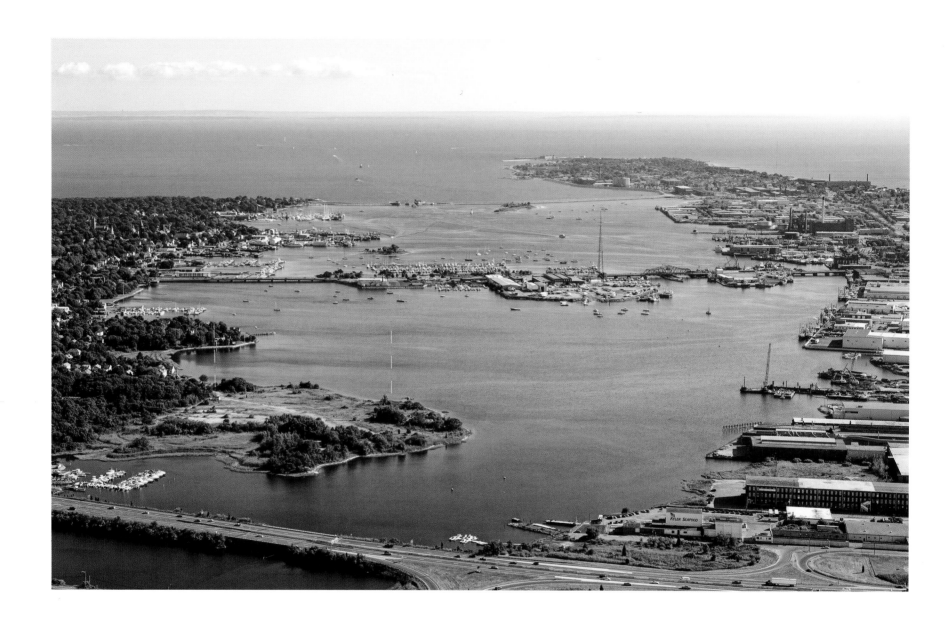

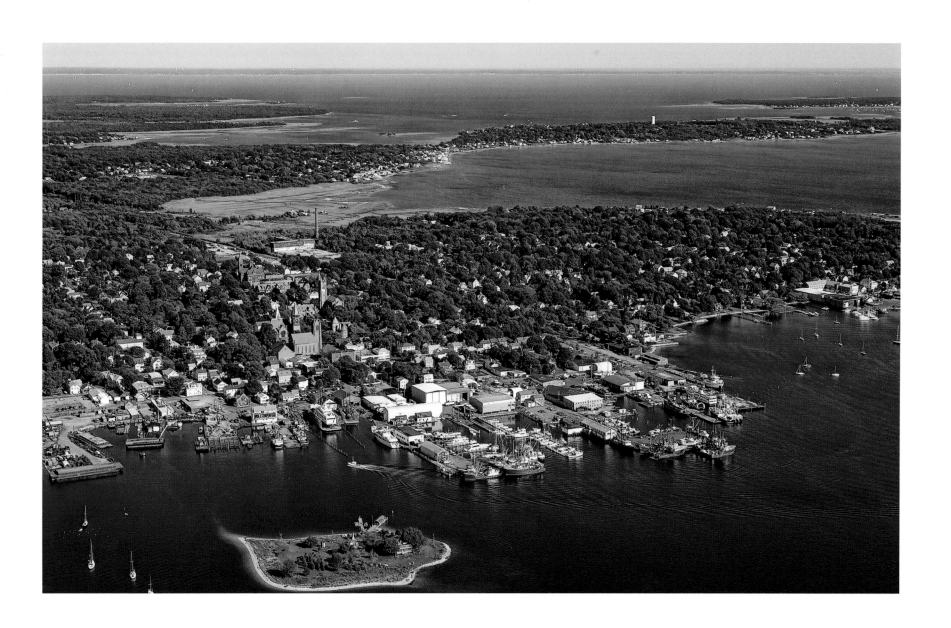

Fairhaven Village, with Sconticut Neck in background 77

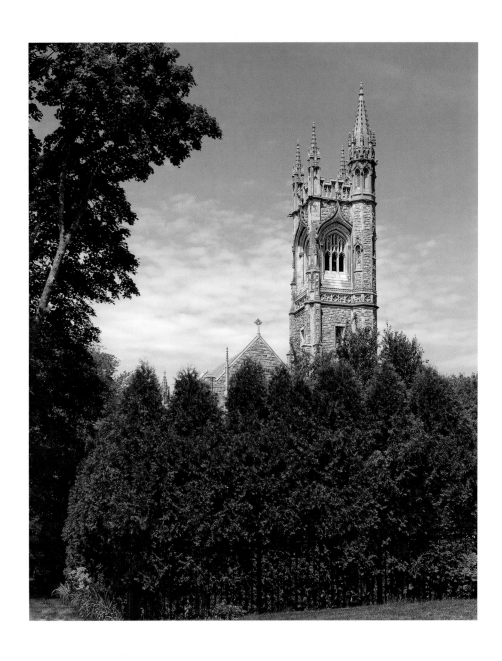

Above: Unitarian Church, Fairhaven
Left: Cranberry bog at harvest time, Acushnet 79

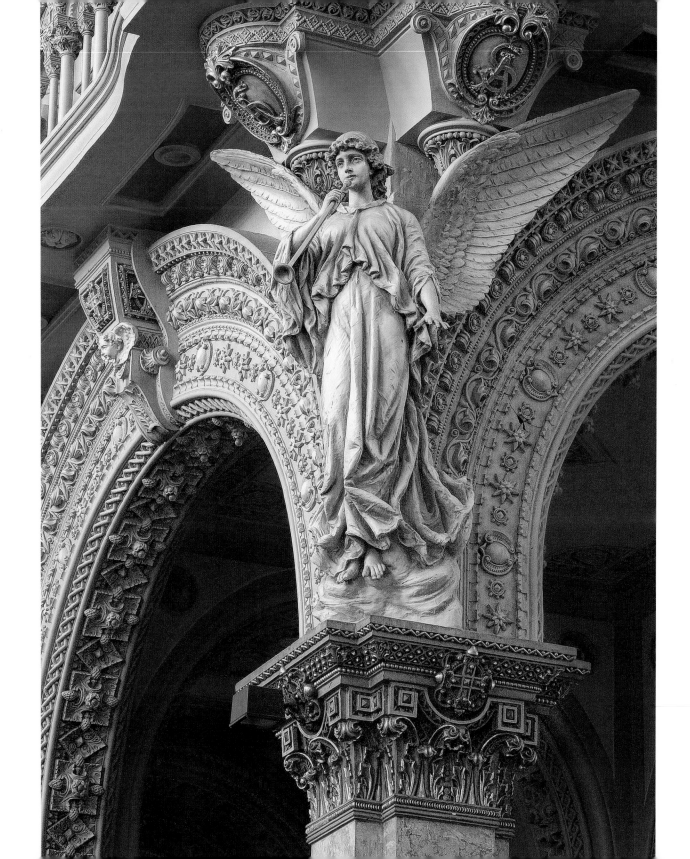

80

Above: Seaman's Bethel on Johnny Cake Hill, New Bedford. Plaques memorialize New Bedford's lost seamen to 2004.
Left: St. Anthony of Padua Church, New Bedford 81

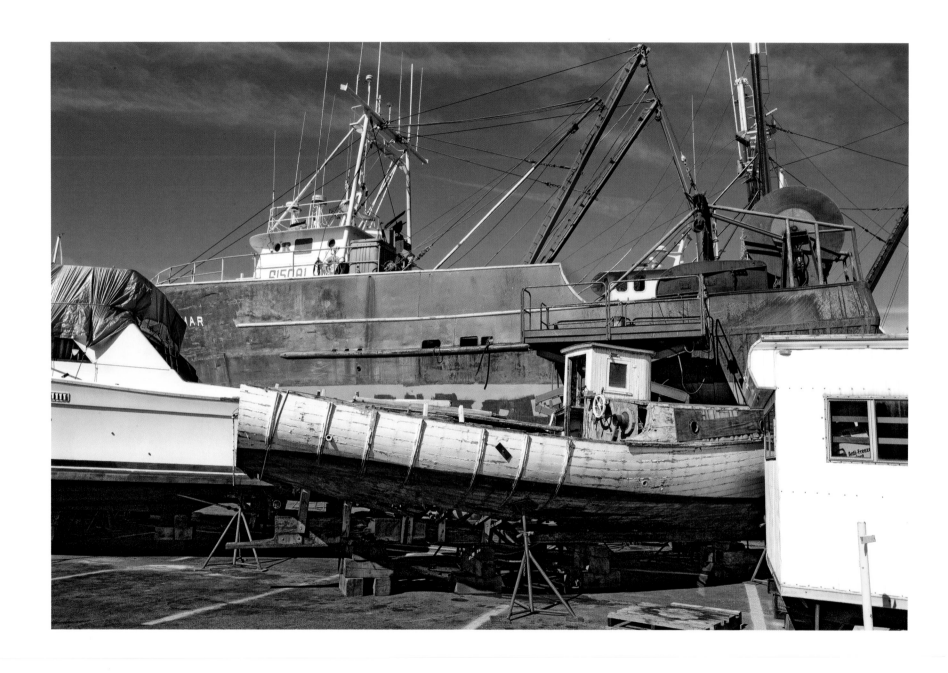

Above: Fairhaven Shipyard

Right: Fishing boats, New Bedford

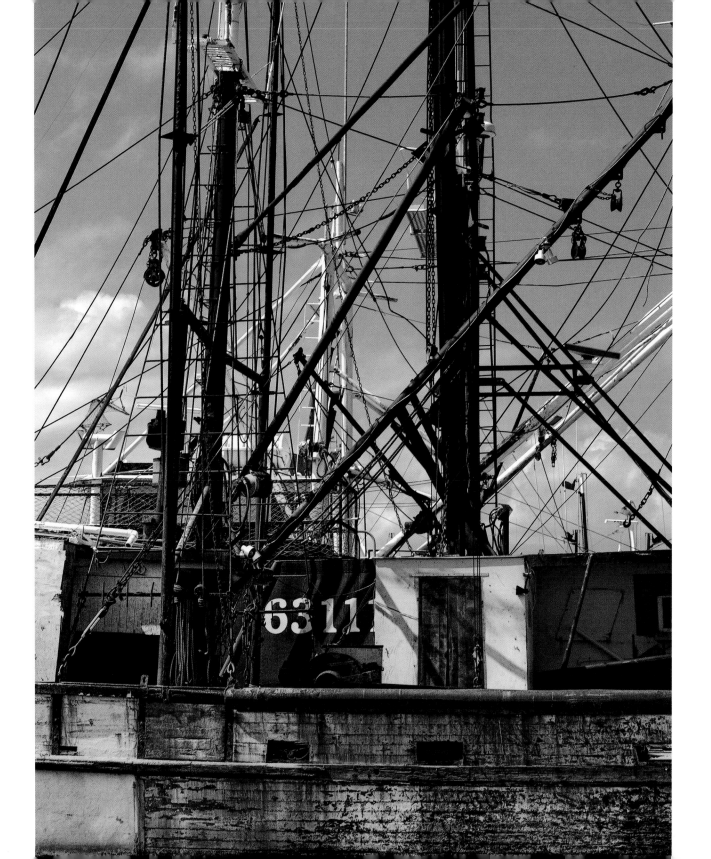

Scallop shucking contest at New Bedford's Working Waterfront Festival

Street concert, part of AHA!, New Bedford's downtown gallery night program 85

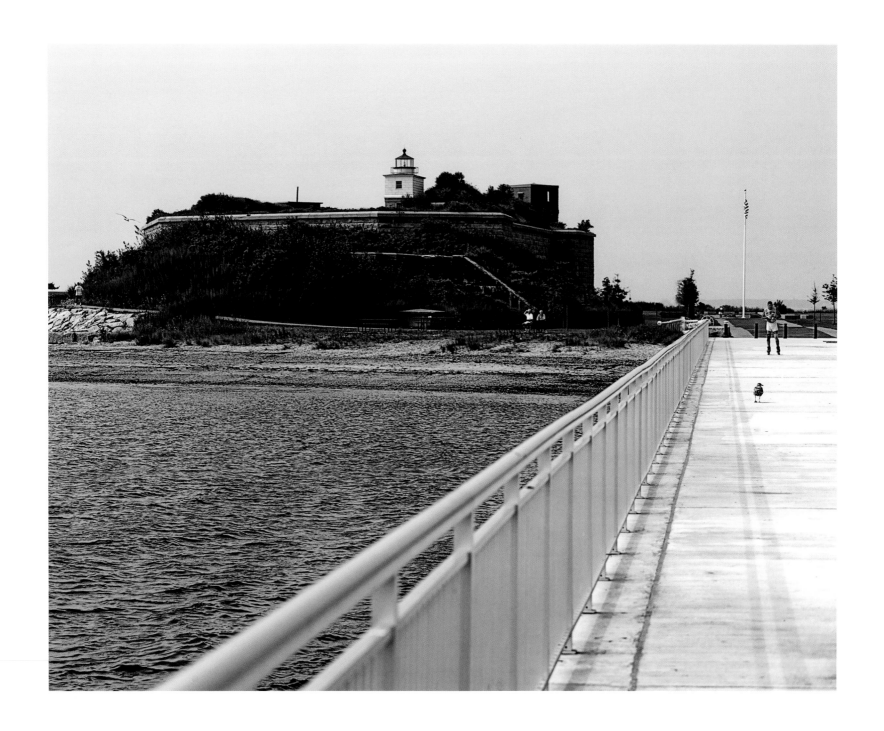

86 Fort Rodman, New Bedford

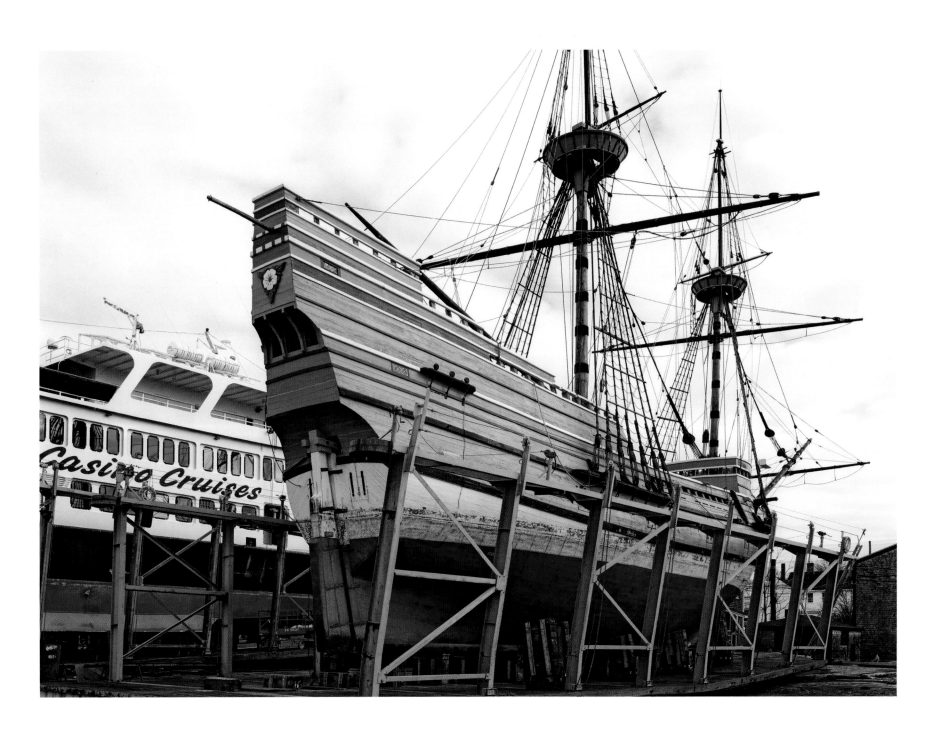

Mayflower and *Stardancer IV* on the ways at Kelley's marine railway 87

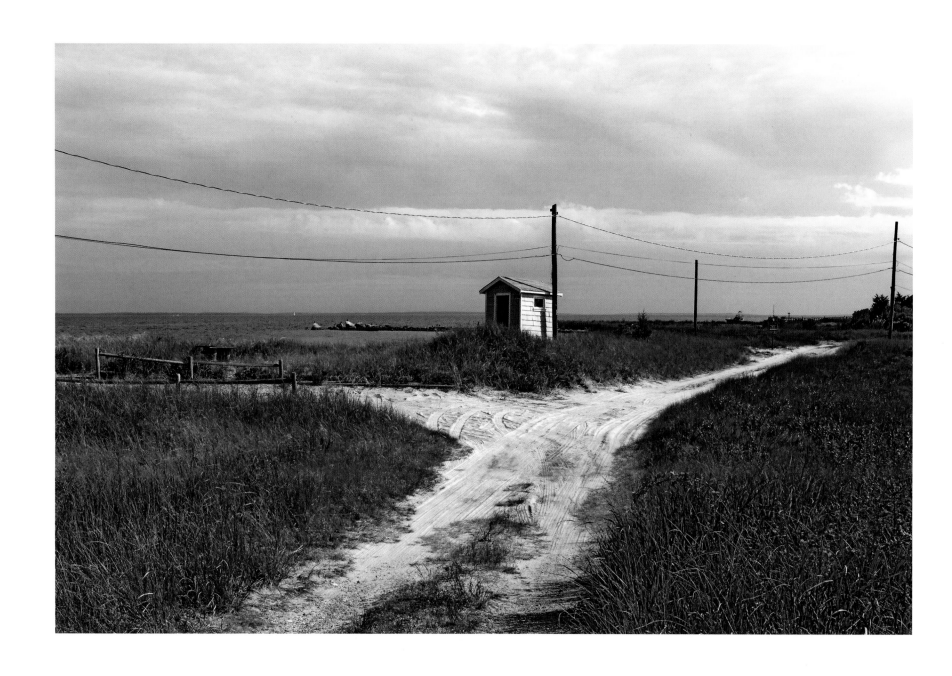

Above: Shack, Sconticut Neck

Right: *Sippican* and *Neisha-Ann*, fishing boat graveyard, New Bedford

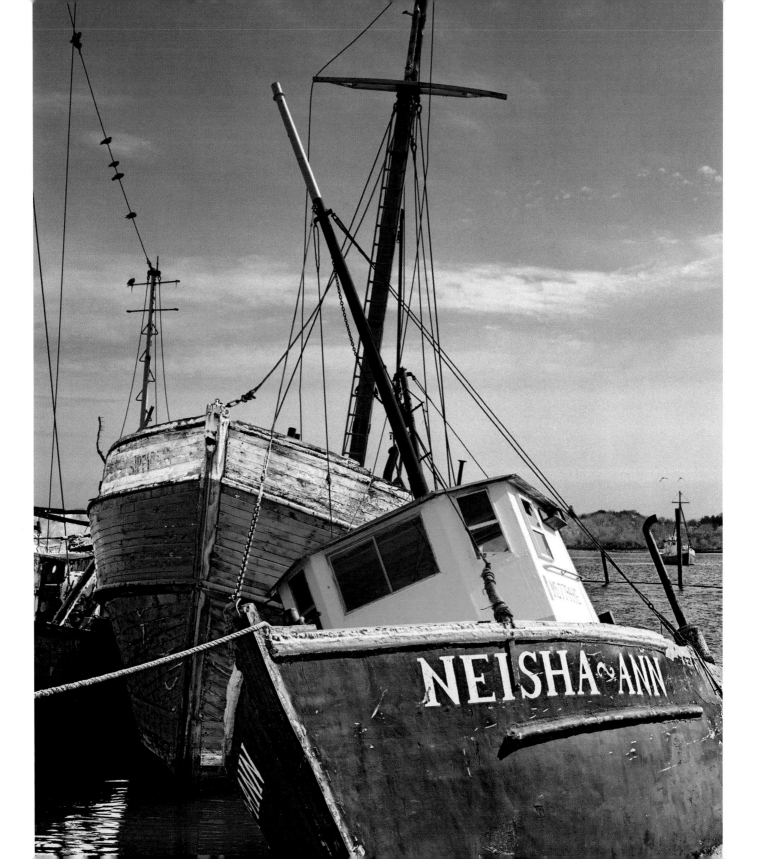

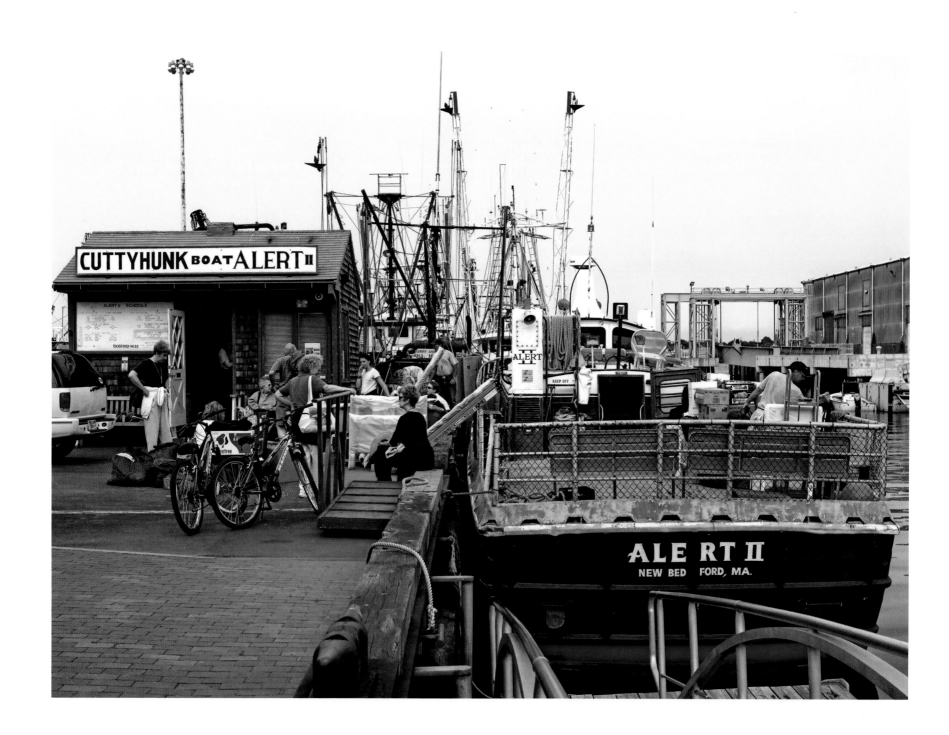

90 Waiting for the Cuttyhunk boat, New Bedford

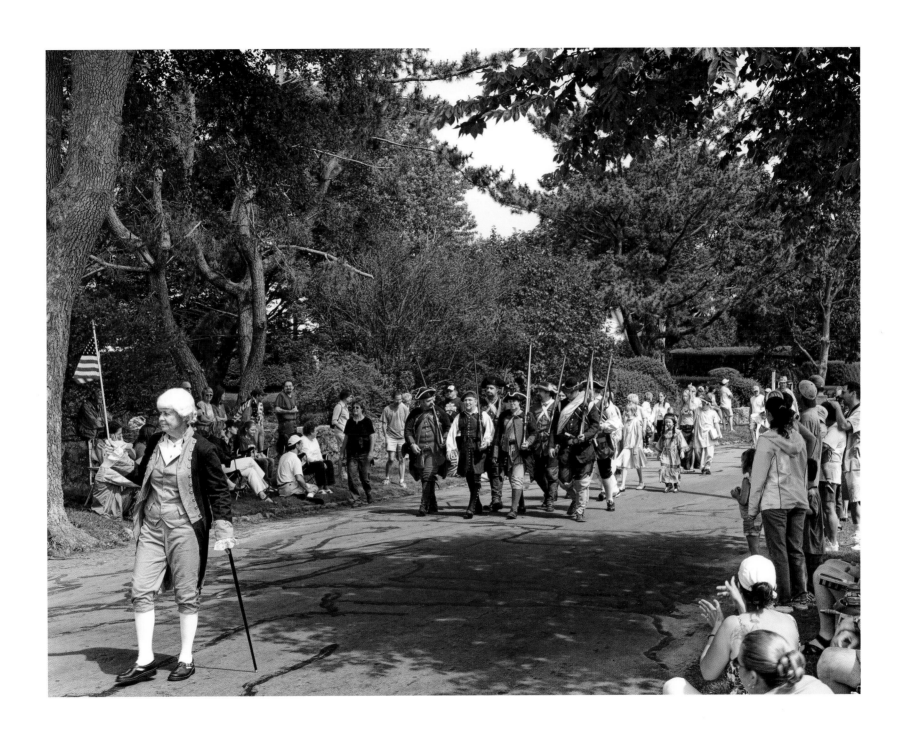

July 4th parade, Fairhaven 91

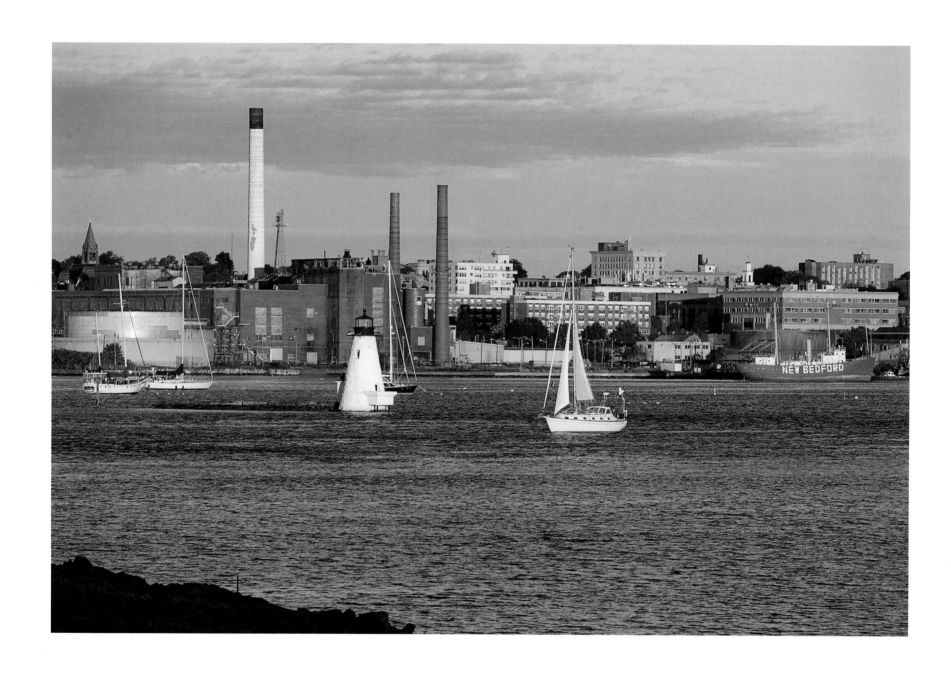

92 New Bedford skyline at dawn

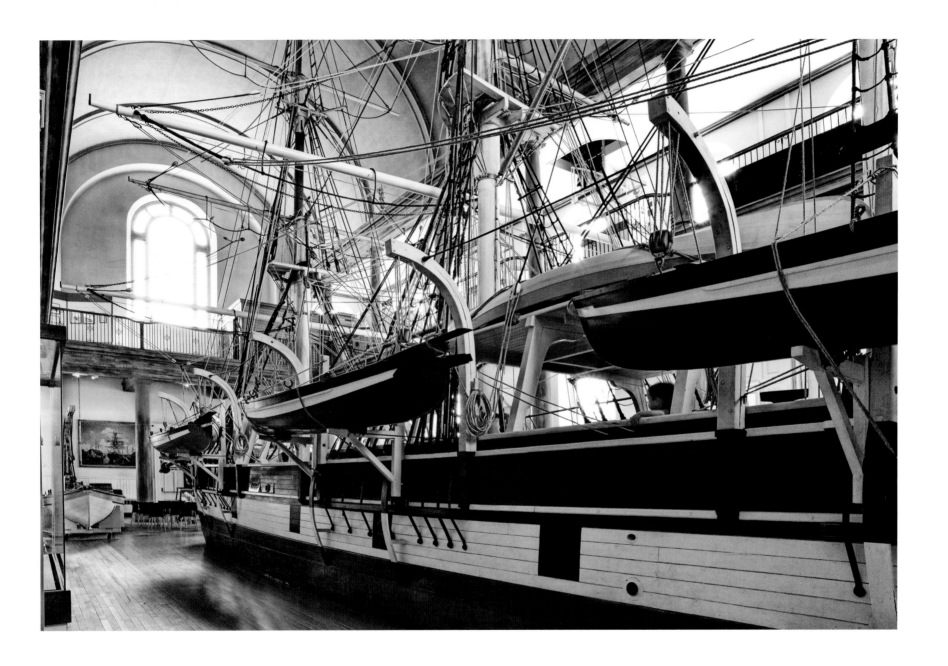

Lagoda at New Bedford Whaling Museum. A five-year-old boy can feel like the skipper aboard this half-scale model of an 1800s whaling ship.

94 Custom House Square, New Bedford

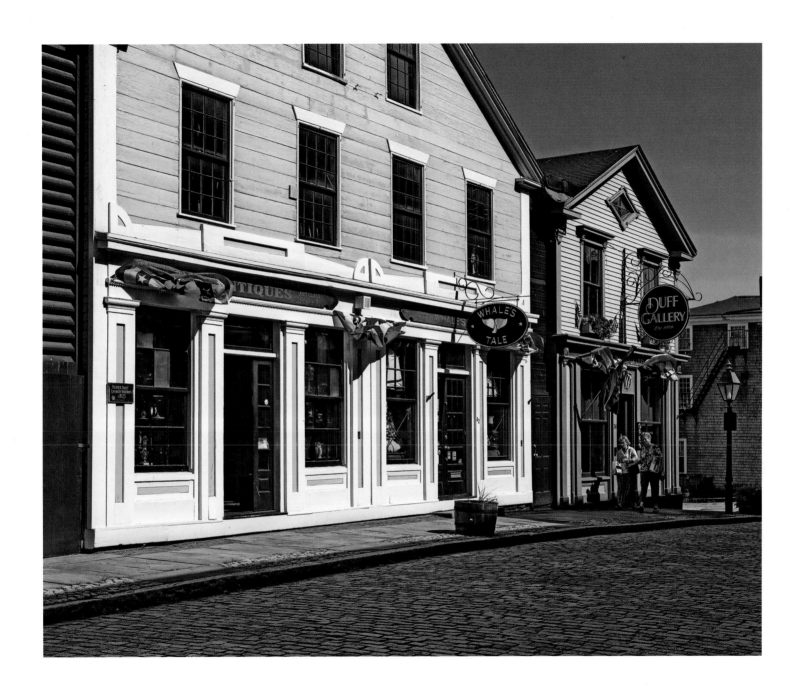

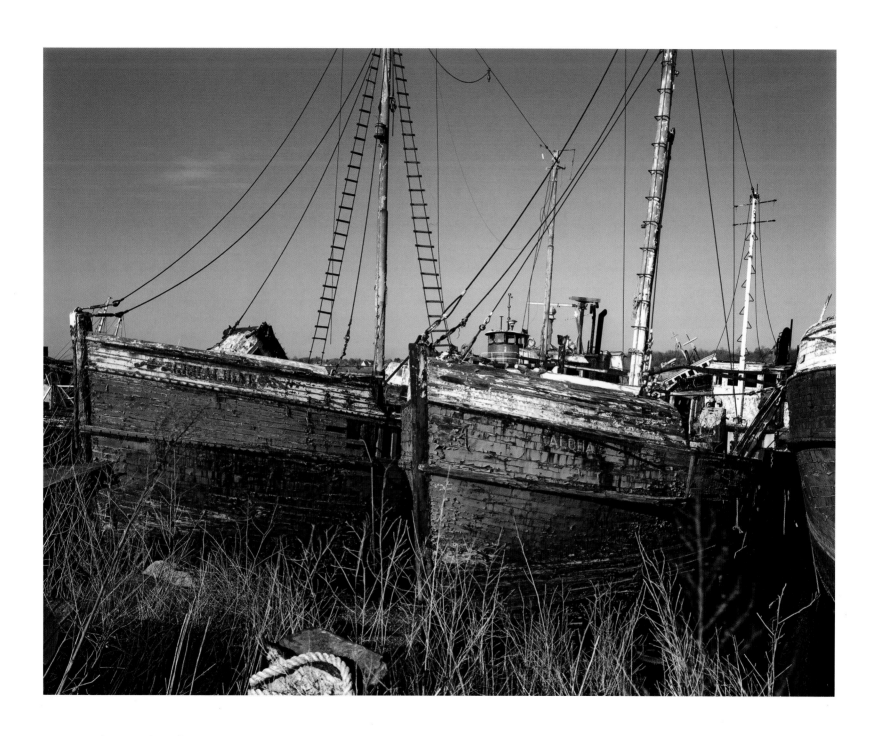

Above: Fishing boat graveyard—*Geraldine* and *Aloha*

Right: *Ernestina* in dry dock, Fairhaven

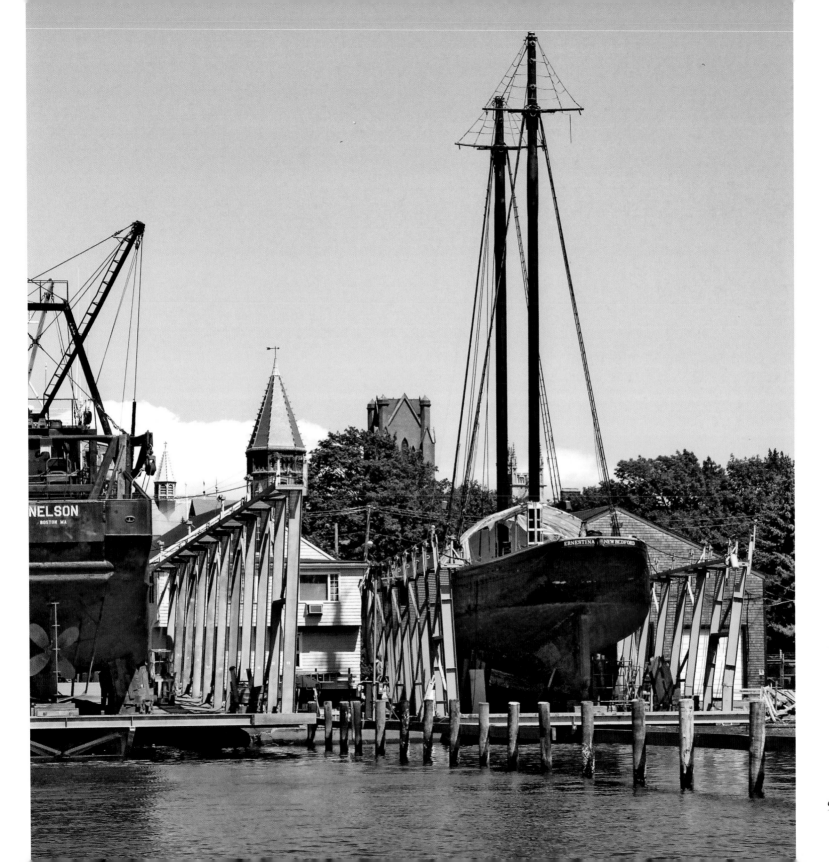

COUNTRY

Dartmouth and Westport are characterized by stone walls, saltwater farms, beautiful rivers, and coastal marshes. Horseneck Beach attracts summer bathers from all over the area in July and August. Wisps of mist drift over Padanaram Harbor at dawn in autumn, while the marshes at Westport Point turn to a glowing amber. Observe the old homes on Westport Point, along with its commercial wharf and lobster market. Drive along Main Road in Westport to see hard-scrabble farming, New England–style. Visit the mill pond at Russell's Mills, and enjoy the curves and hills on Rock o' Dundee Road. And don't miss the kayak trip down the Little River in Dartmouth.

Above: East Beach Road, Westport Point
98 Right: Cove, Westport Point

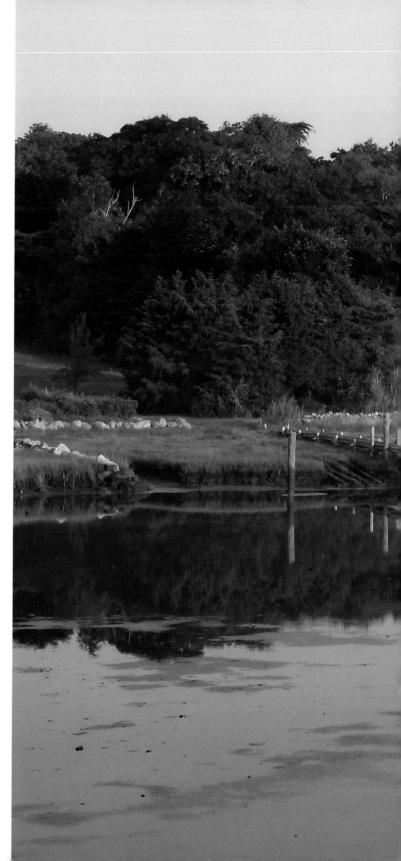

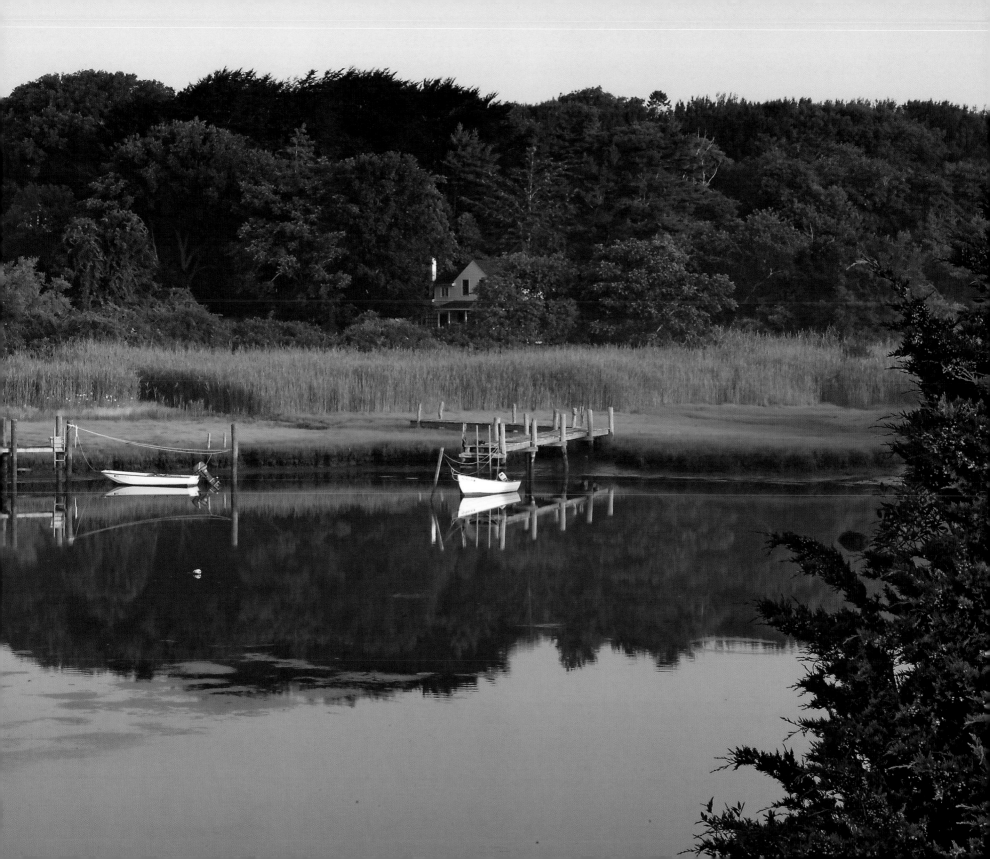

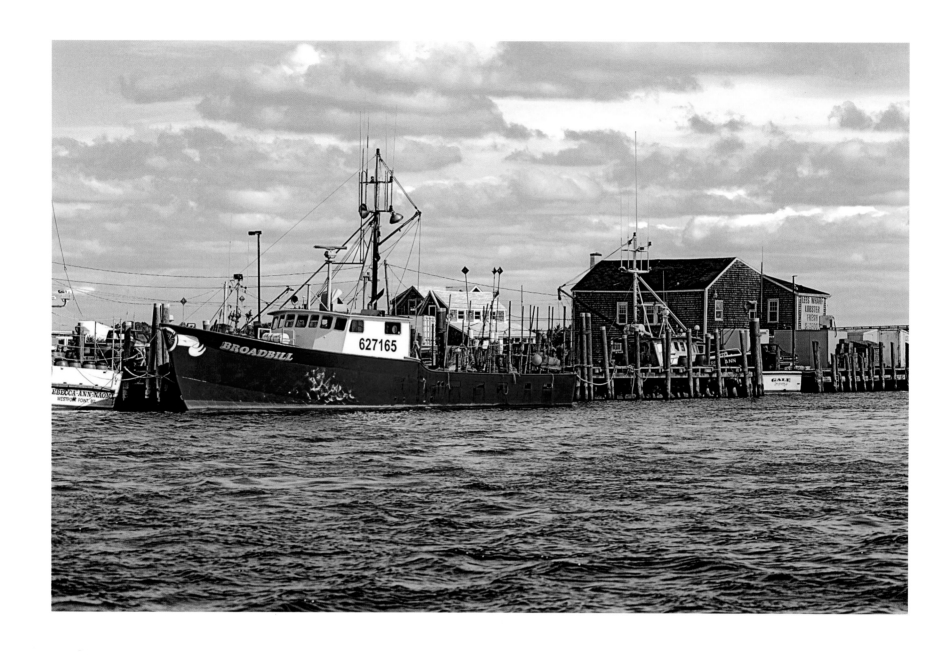

Lees commercial wharf, Westport Point

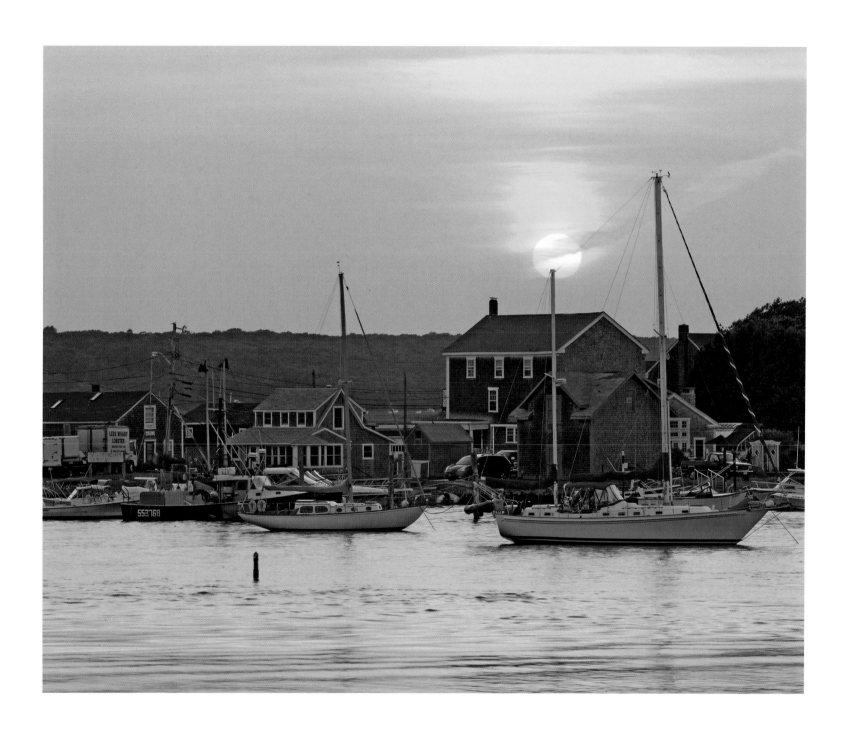

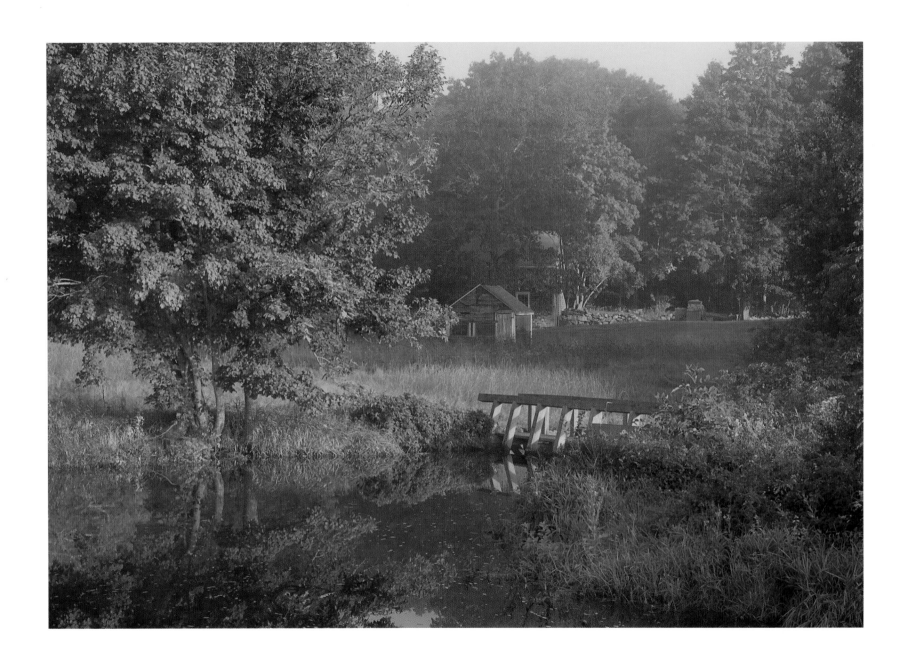

102 Gray's Mill Pond, off Adamsville Road, Westport. The Massachusetts–Rhode Island border lies about fifty feet beyond the edge of the pond.

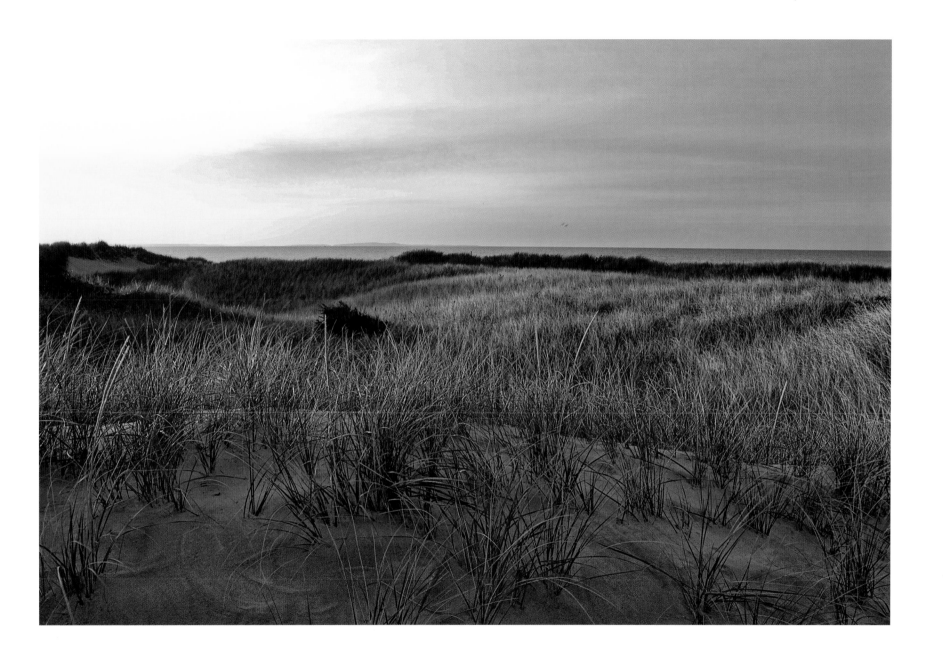

Dunes near Allen's Pond, Dartmouth 103

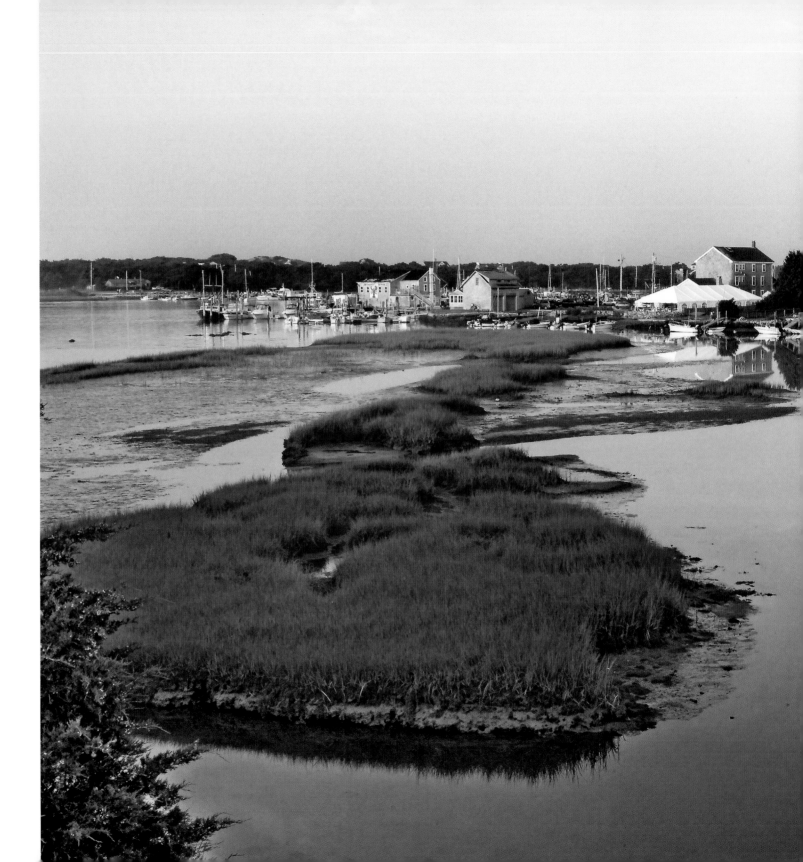

Morning,
Westport Point

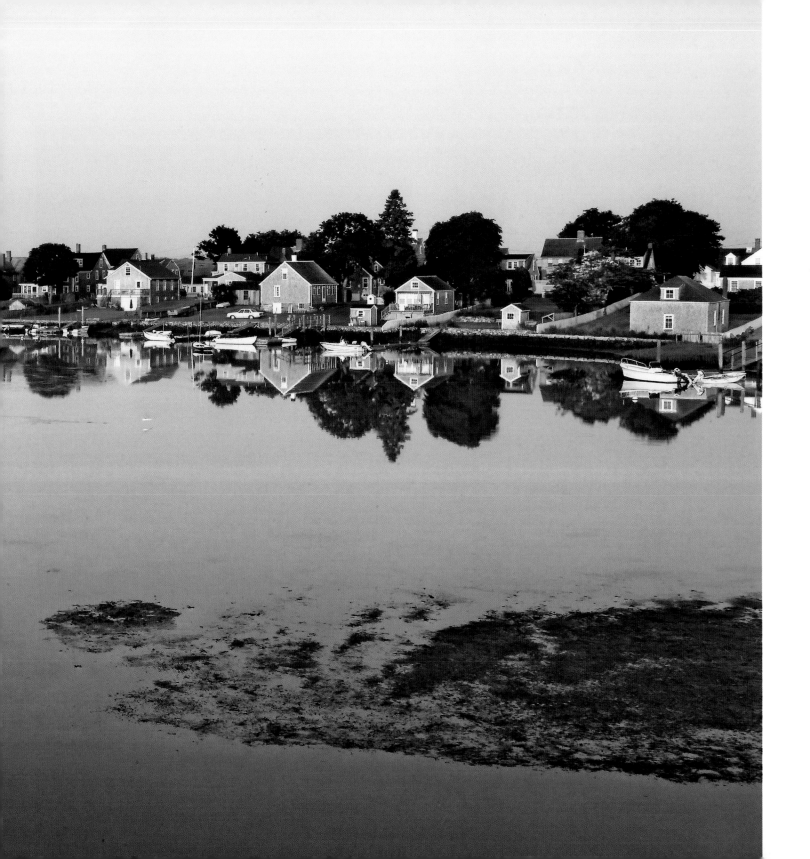

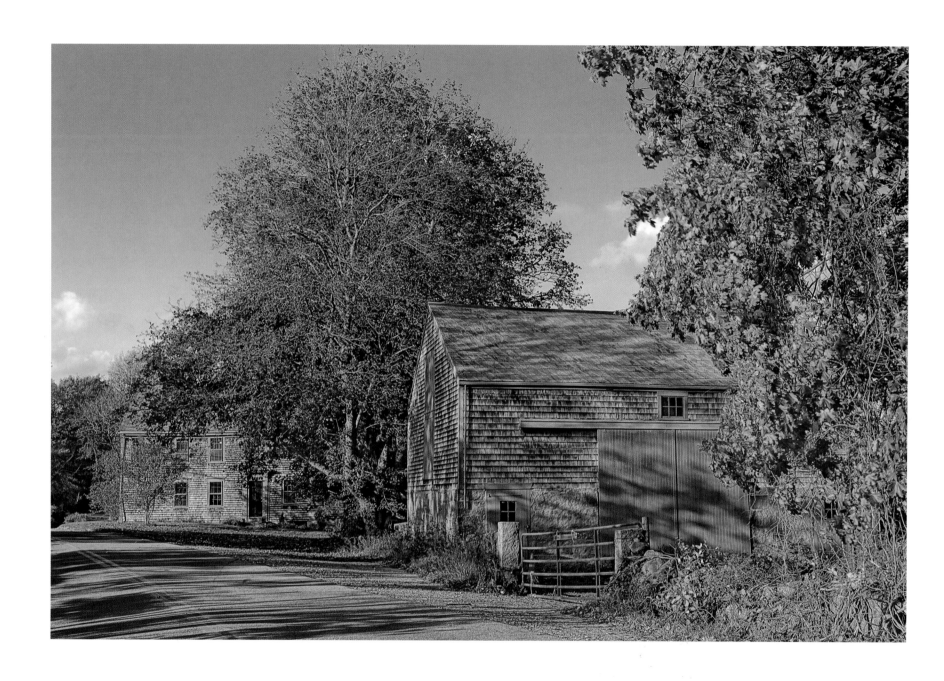

106 Drift Road farm, Westport

Lloyd Center Viewscape, Dartmouth 107

108 Westport Rivers Vineyard, Westport

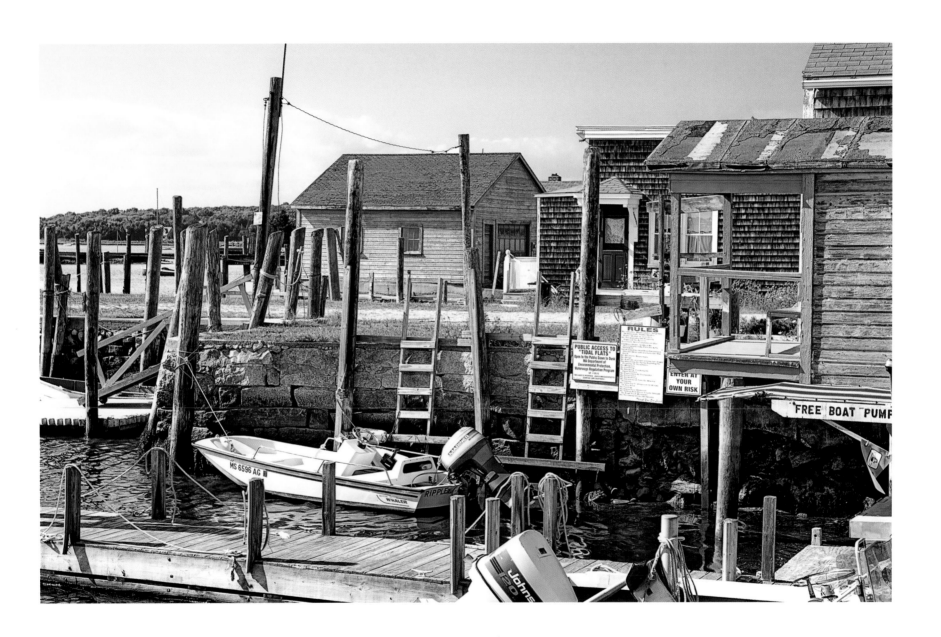

Boats and docks, Westport Point 109

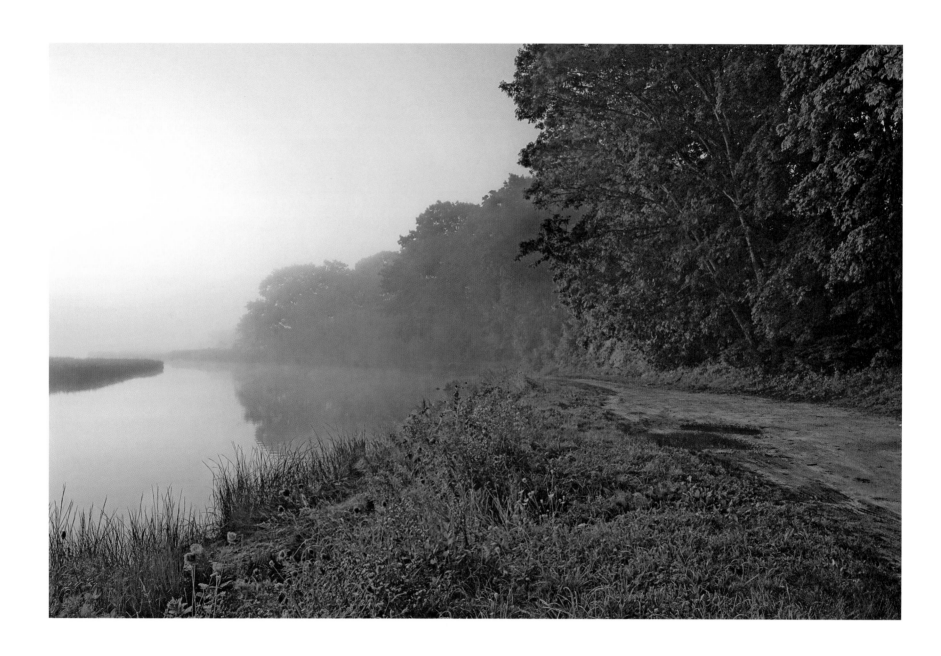

110　　Westport-Adamsville (Rhode Island) small-boat landing

Scottish highland cattle, Dartmouth 111

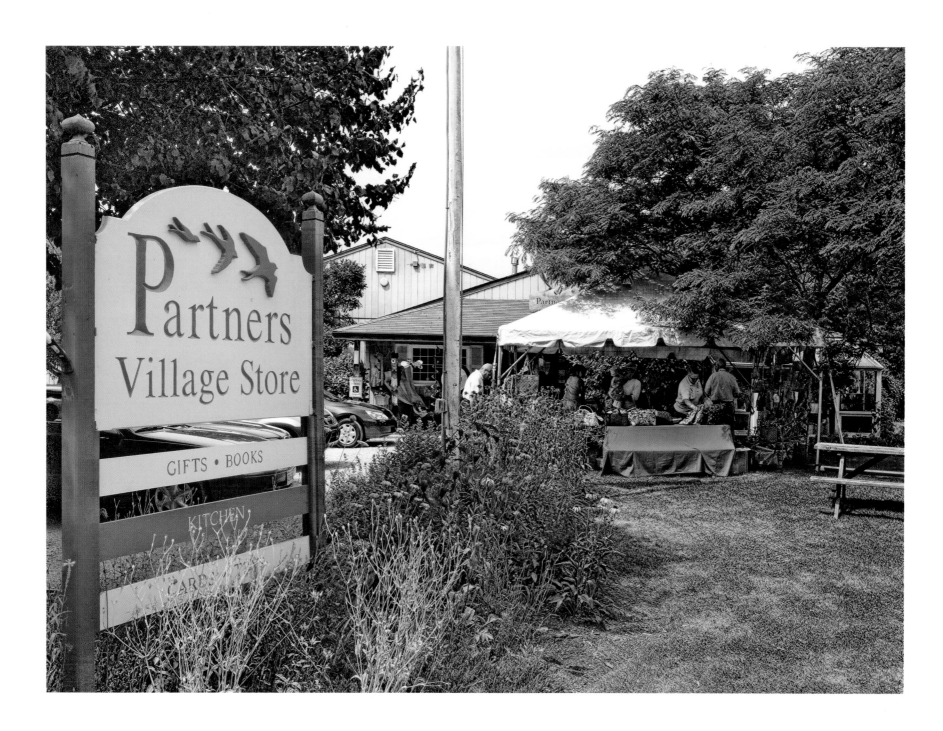

Partners Village Store, Westport Central Village

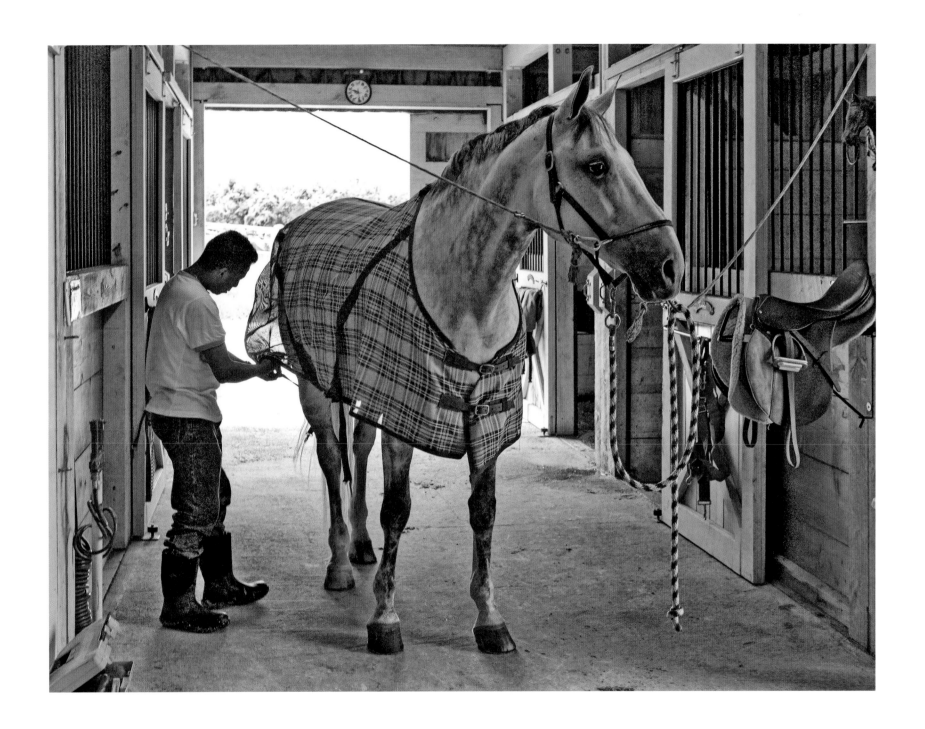

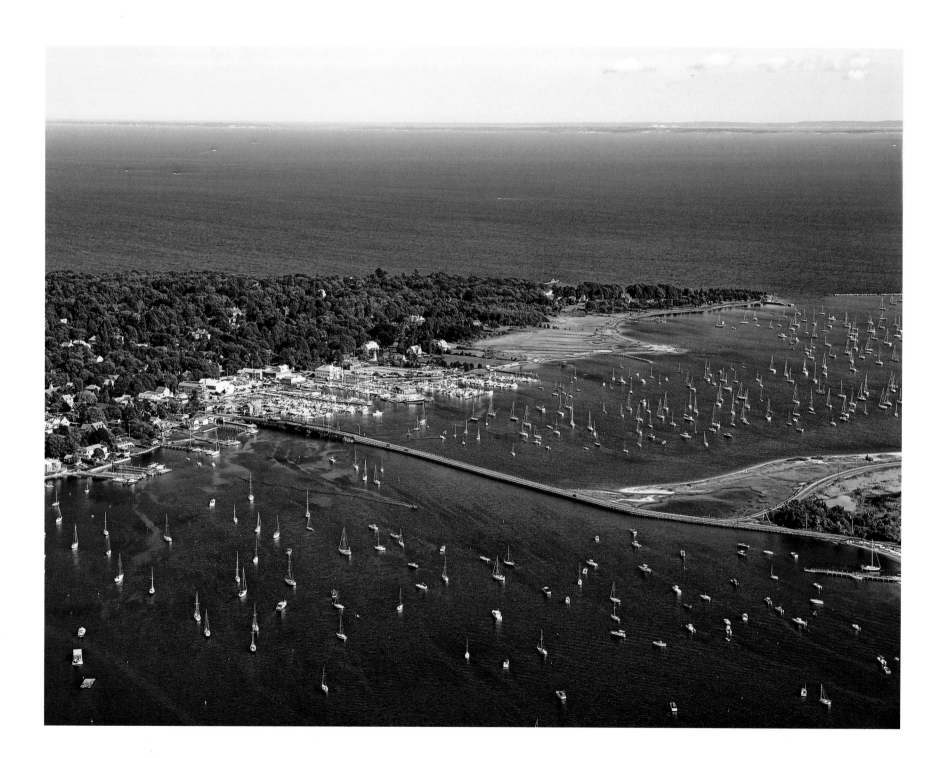

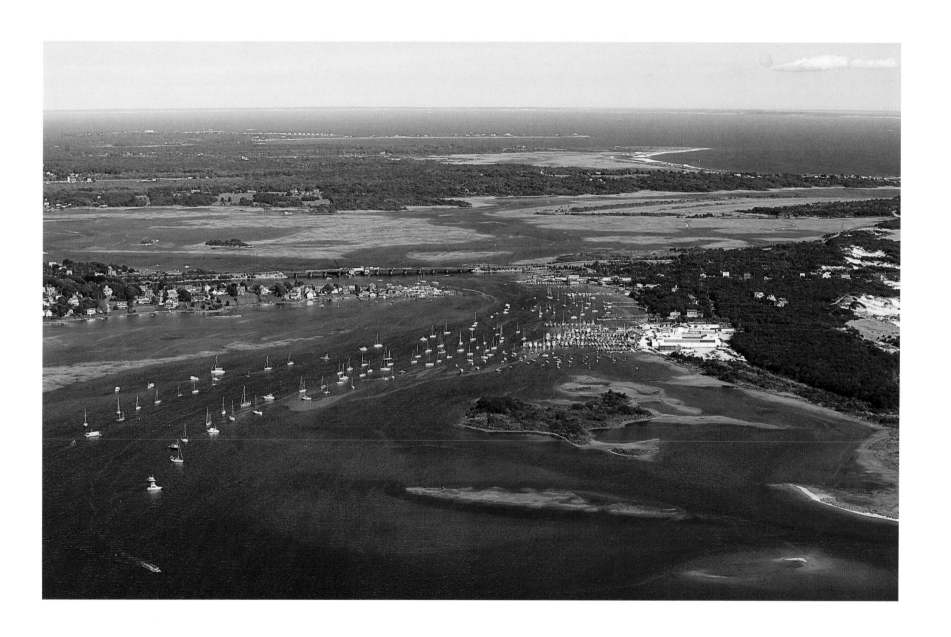

Above: Westport Harbor
Left: Padanaram Harbor, Dartmouth 115

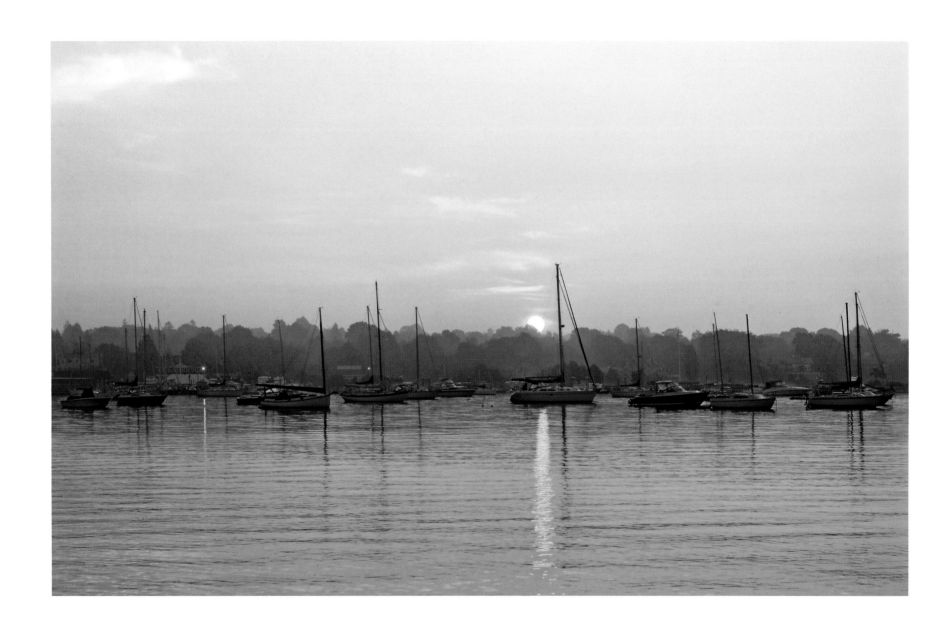

116 Sunrise over Padanaram Harbor, Dartmouth

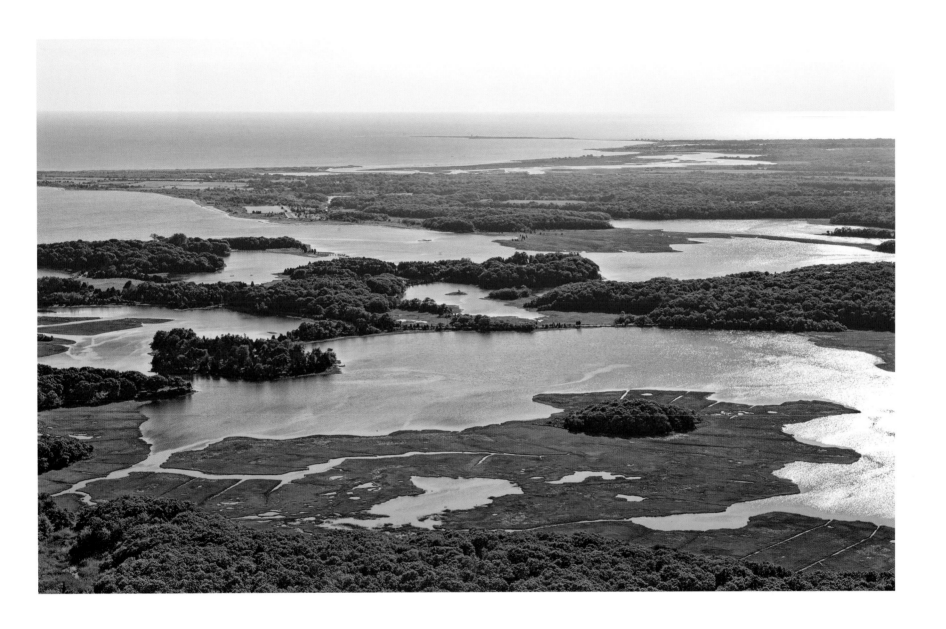

The outlets of the Little and Slocum rivers, Dartmouth 117

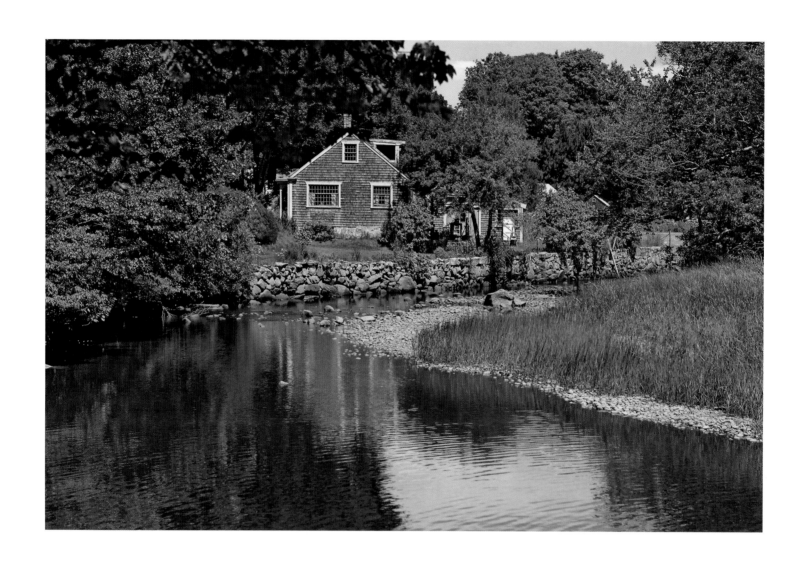

Above: Slocum River at Russell's Mills, Dartmouth
118 Right: Dunes near Allen's Pond, Dartmouth

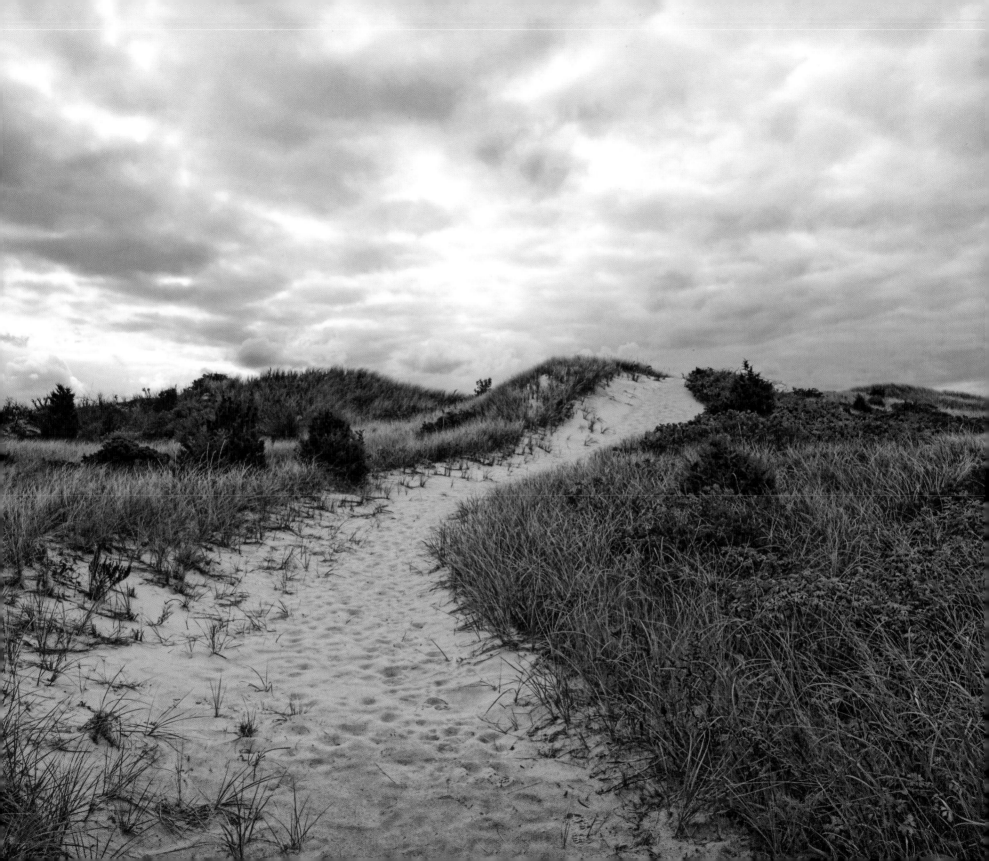

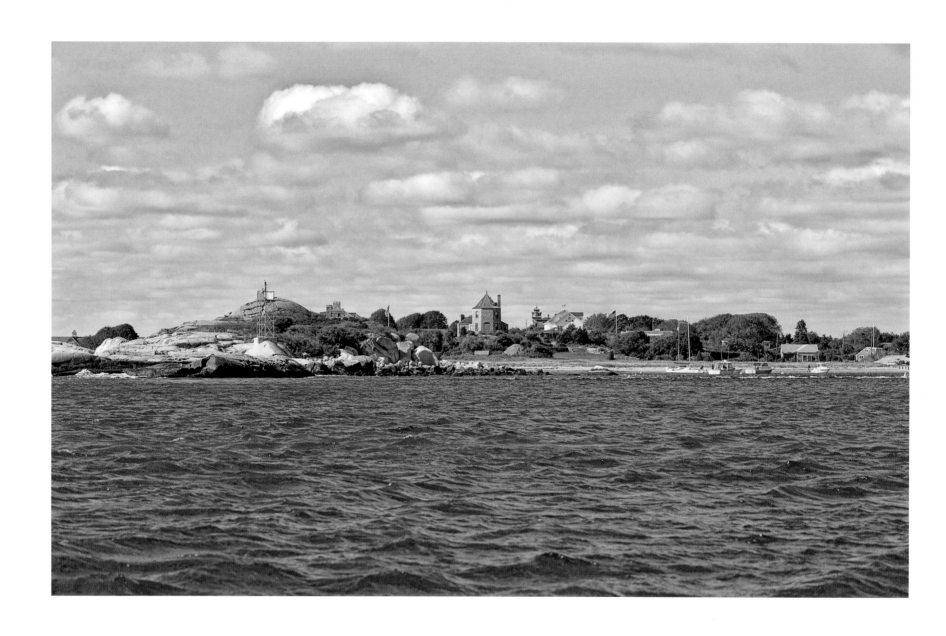

120 Acoaxet, from Westport Harbor entrance. Acoaxet is the western edge of Westport and the South Coast.

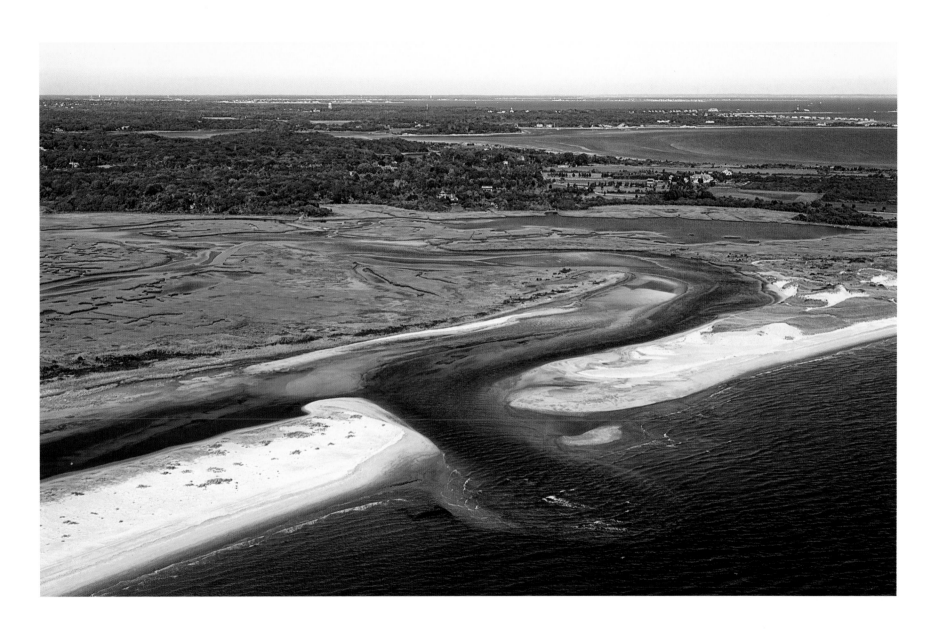

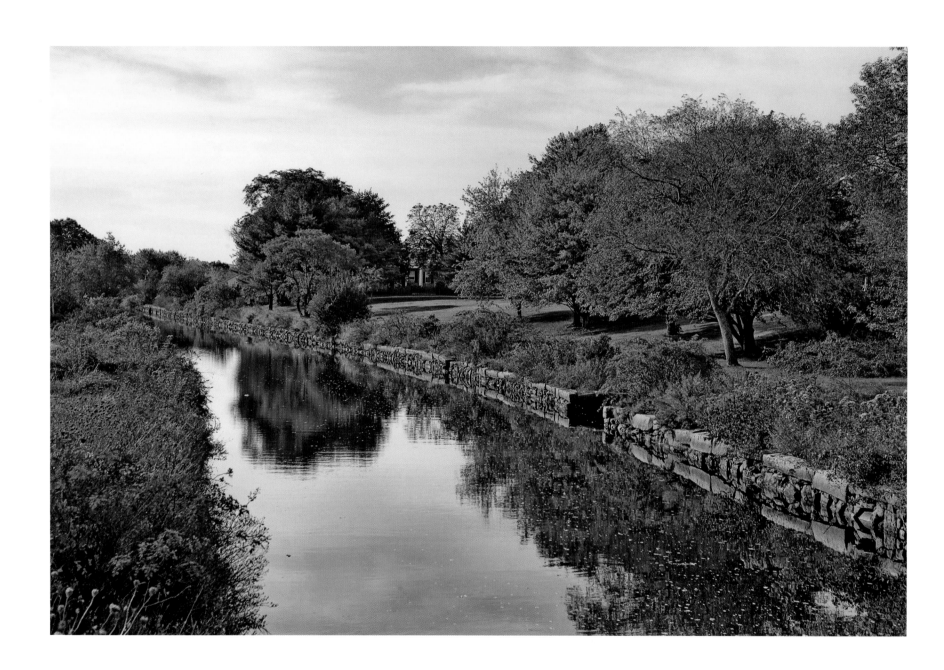

East Branch of Westport River at Head of Westport

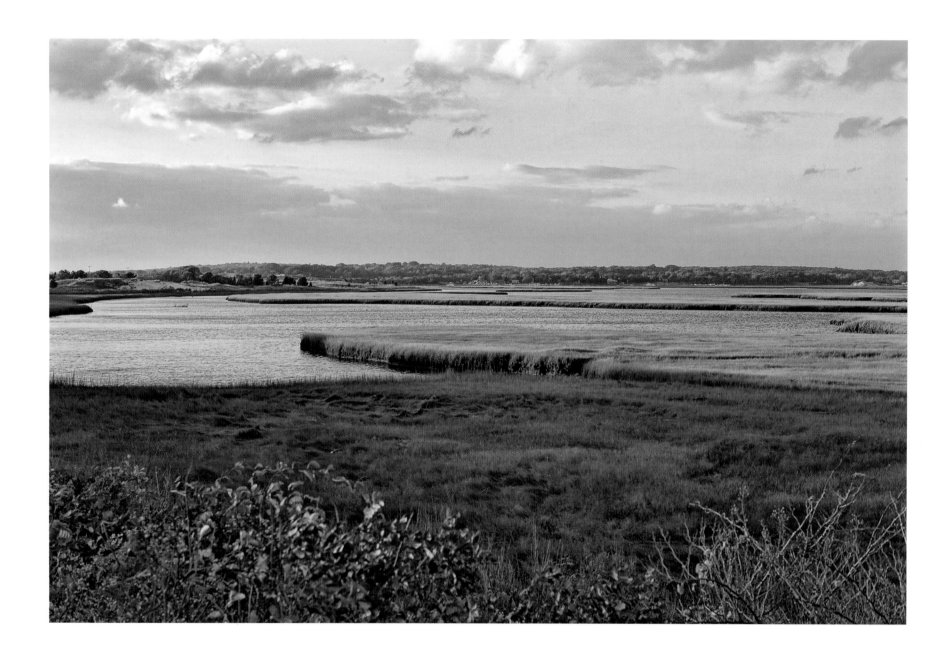

124 Westport River marsh

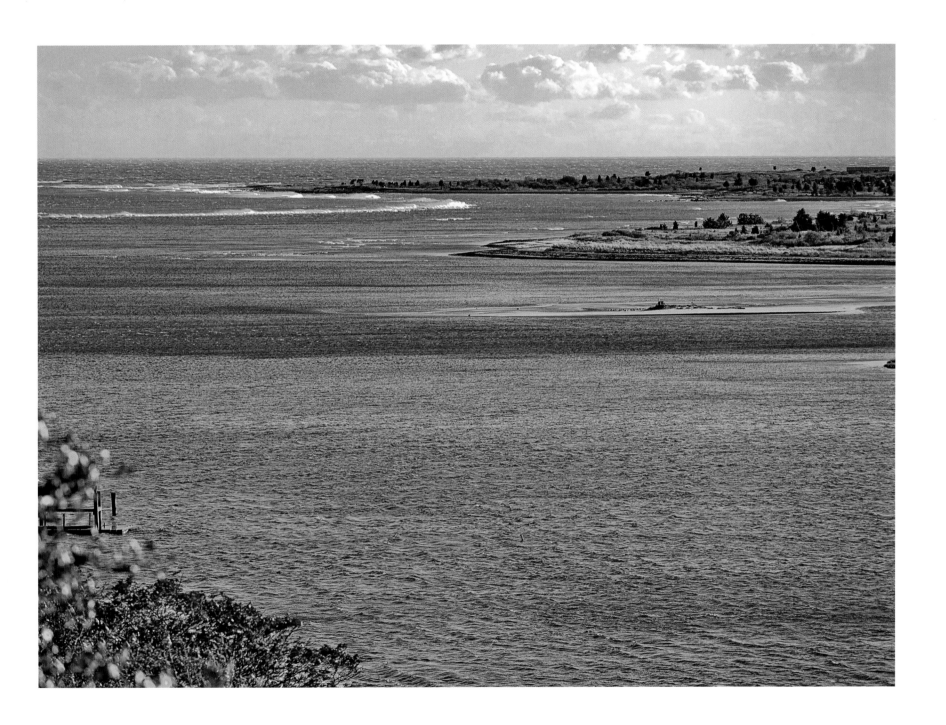

Slocum River outlet, Dartmouth 125

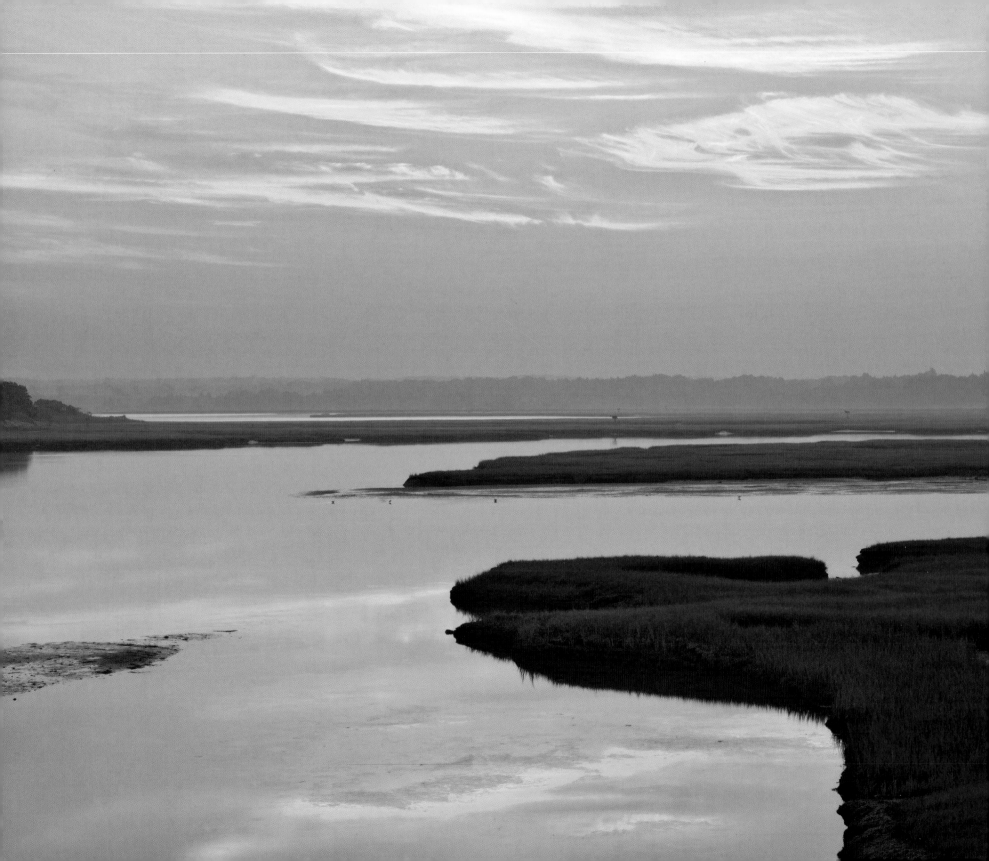

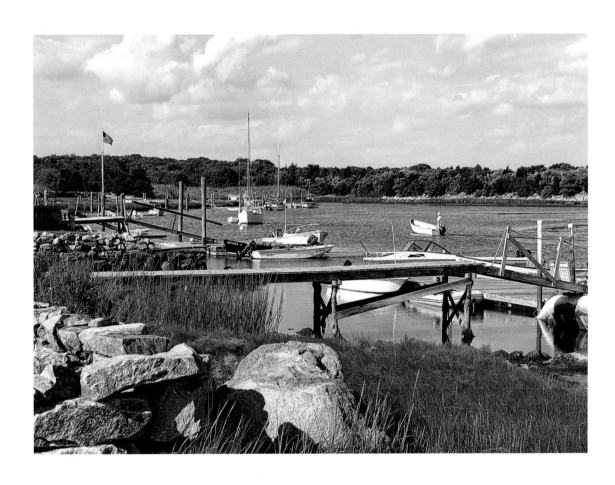

Above: Boats and docks, Westport Point
Left: East Branch of Westport River, Westport Point 127

THE EDGE OF THE BAY

My wife and I moved from Newton, Massachusetts, to Marion in 1966. In our first evening we drove to Mattapoisett for dinner. During the six-mile drive we met only one other car. Life here was going to be vastly different from that in the Boston suburb—slower and quieter. In those days nobody I met spoke of the South Coast; it was just the edge of Buzzards Bay. Since then our lives have sped up and the trendy "SouthCoast" has become the catchword of an economic development movement. That SouthCoast includes twelve towns running from Wareham to Fall River and Lakeville. Some of us think of a more amorphous "South Coast" that implies a strong connection to Buzzards Bay and its history.

To me the communities along the edge of the bay are the essence of the South Coast. The pattern of alternating harbors and peninsulas has allowed each town to develop its own personality, while they all share an aura of history and solidity. Visually, the shoreline is paramount and an unending attraction to artists and photographers. Its beaches, marshes, and boatyards have changed little since we arrived in 1966, giving spectators like me a continuous opportunity to record the many moods of the land, water, and atmosphere.

I've been a photographer since I was twelve. While a student at MIT, I took the portraits of department heads for the yearbook. Since then I've specialized in landscape and architectural photography, plus the usual family shots. In the early 1990s I lived part-time in British Columbia, where I bought a view camera (the kind that has a big bellows and needs a tripod) and photographed the spectacular Canadian mountains and shores. When I left engineering in 1993, I started photographing the South Coast in earnest. In many ways the South Coast is more rewarding photographically than British Columbia. The Canadian mountains are monumental, while our eastern marshes are nuanced and moody and more on a human scale. Few scenes are as meaningful to me as that of wisps of sea smoke hovering over a calm harbor or cove during an October sunrise. Even gray November clouds seen over a sand dune in Dartmouth can evoke an emotional response. The intricacy of the bay shoreline seen from an airplane at a thousand feet is a fascination. That's why this collection of pictures concentrates on shorelines and waterfronts. And there's much more to the South Coast than can be captured in a single volume.

This book is the product of innumerable early mornings and darkroom hours—although the digital revolution has now made the darkroom obsolete. It's also the product of guidance and assistance from many people including Steve Sperry, my pilot for the aerial shots. Thanks to publisher Webster Bull and book designer Anne Rolland. Richard Benjamin, a great photographer of Rhode Island and a good friend, introduced me to Webster. Andrea Scofield, my partner in the Centre Street Gallery, supported the effort in many ways. Louise Rogers and Carole Rogers of the Rogers Gallery helped select the images for the book. Mary Ann and Norman LaMontagne gave me a nautical tour of the Westport River. Debbie and Bob Bergeron of Tri-Color Labs processed all my film and gave advice. Many thanks to Msgr. Edmond Levesque (now retired), who guided me through the marvelous Saint Anthony's church. Jan Hall checked the text and captions. Christina Hingston, Janice Brown, and Bob Duff offered advice and cheers. And finally, my wife Maud was involved from start to finish.

Large-format archival giclée prints of my photographs are available at the Centre Street Gallery in New Bedford, the Rogers Gallery in Mattapoisett, and Partners Village Store in Westport Central Village.

Robert N. Linde
Marion, Massachusetts